FAMBUL TOK

FAMBUL TOK

Foreword by
ISHMAEL BEAH

Interview with
JOHN CAULKER

Photographs by
SARA TERRY

Essays by
LIBBY HOFFMAN and SARA TERRY

Afterword by
BENEDICT SANNOH

UMBRAGE EDITIONS NEW YORK

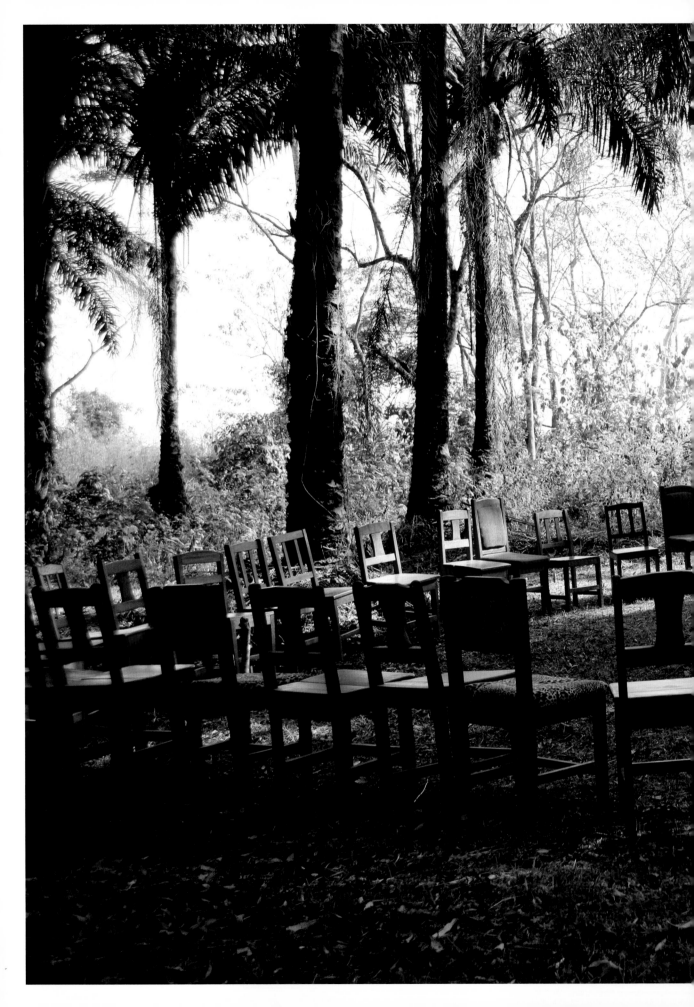

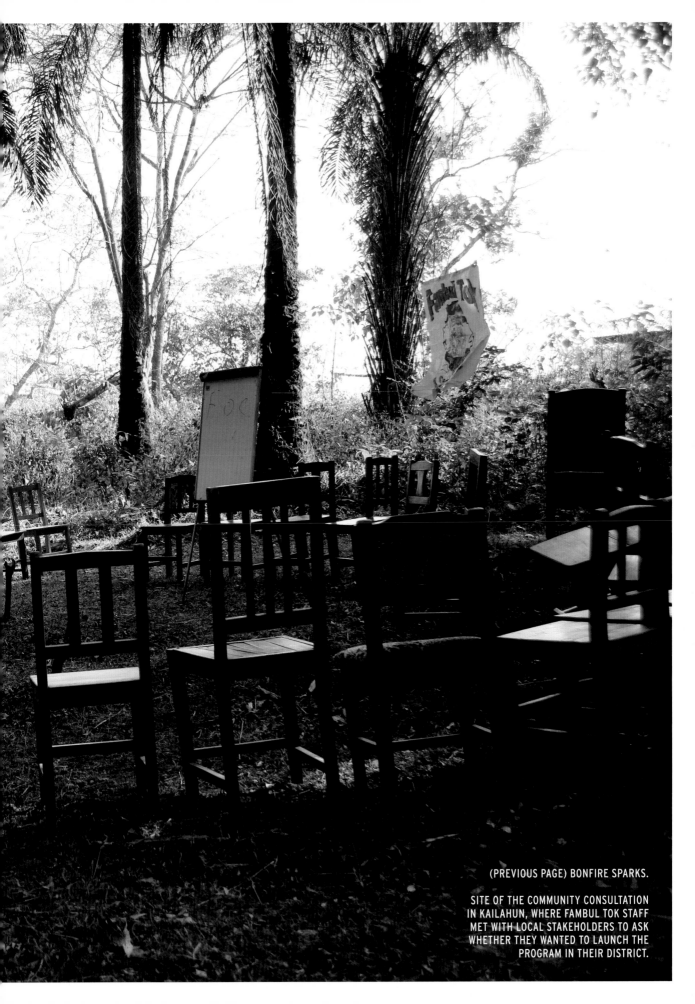

(PREVIOUS PAGE) BONFIRE SPARKS.

SITE OF THE COMMUNITY CONSULTATION IN KAILAHUN, WHERE FAMBUL TOK STAFF MET WITH LOCAL STAKEHOLDERS TO ASK WHETHER THEY WANTED TO LAUNCH THE PROGRAM IN THEIR DISTRICT.

FAMBUL TOK ("family talk" in Krio, the Sierra Leonean lingua franca) emerged in Sierra Leone as a face-to-face community-owned program that brings together perpetrators and victims of the violence from Sierra Leone's eleven-year civil war for the first time since the war ended. They meet through ceremonies rooted in the traditions of the villages affected by this violence. At evening bonfire ceremonies, victims give voice to their memories, and perpetrators confess. They can ask for, and offer, forgiveness, preparing the way for individuals and communities to forge a new future — together.

Fambul Tok is built upon Sierra Leone's "family talk" tradition of discussing and resolving issues within the security of the family circle. The program works at the village level to help communities organize ceremonies that include truth-telling bonfires and traditional cleansing ceremonies — practices that many communities have not employed since before the war. After hosting a ceremony, communities engage in a series of follow-up activities to deepen and build upon the reconciliation process and strengthen the community.

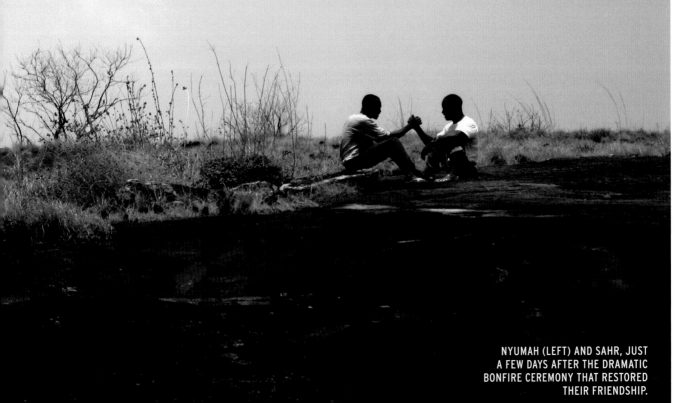

NYUMAH (LEFT) AND SAHR, JUST
A FEW DAYS AFTER THE DRAMATIC
BONFIRE CEREMONY THAT RESTORED
THEIR FRIENDSHIP.

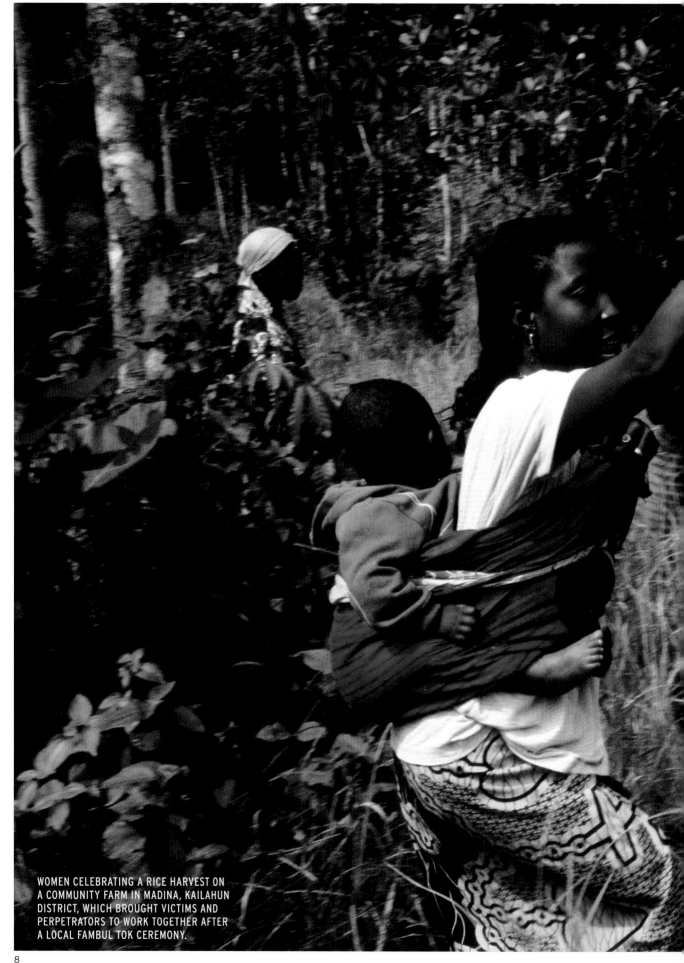

WOMEN CELEBRATING A RICE HARVEST ON
A COMMUNITY FARM IN MADINA, KAILAHUN
DISTRICT, WHICH BROUGHT VICTIMS AND
PERPETRATORS TO WORK TOGETHER AFTER
A LOCAL FAMBUL TOK CEREMONY.

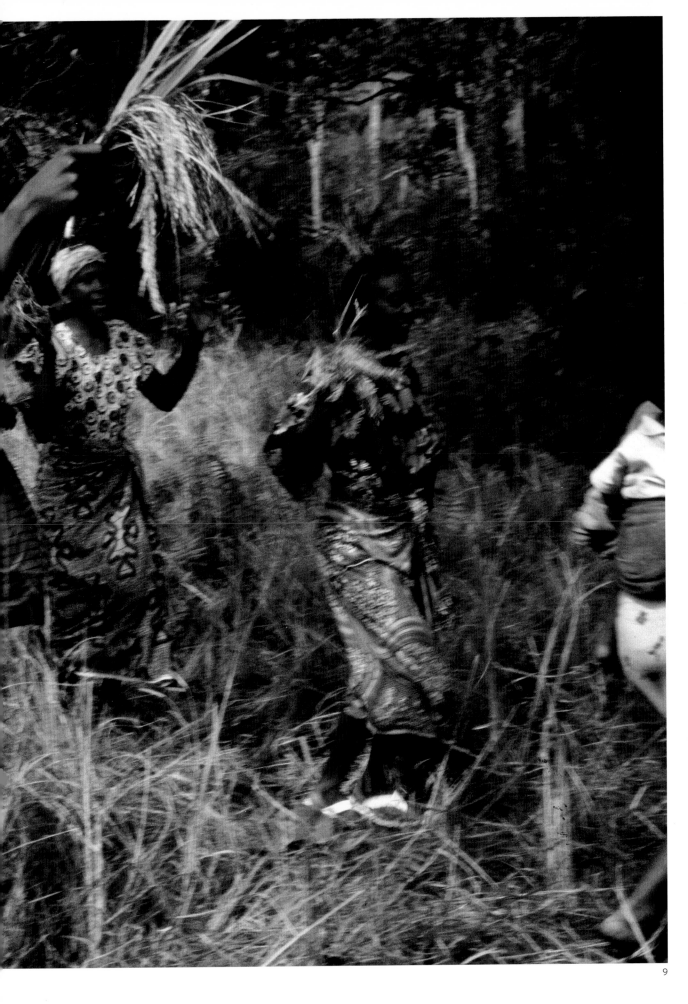

TO THE CHILDREN OF SIERRA LEONE—MAY THESE STORIES BE
LIKE ELDERS IN YOUR LIVES, ALWAYS PRESENT TO GUIDE AND
ILLUMINATE THE BEST IN YOURSELVES AND YOUR COUNTRY.

-JOHN CAULKER AND LIBBY HOFFMAN

SIERRA LEONE COUNTRYSIDE.

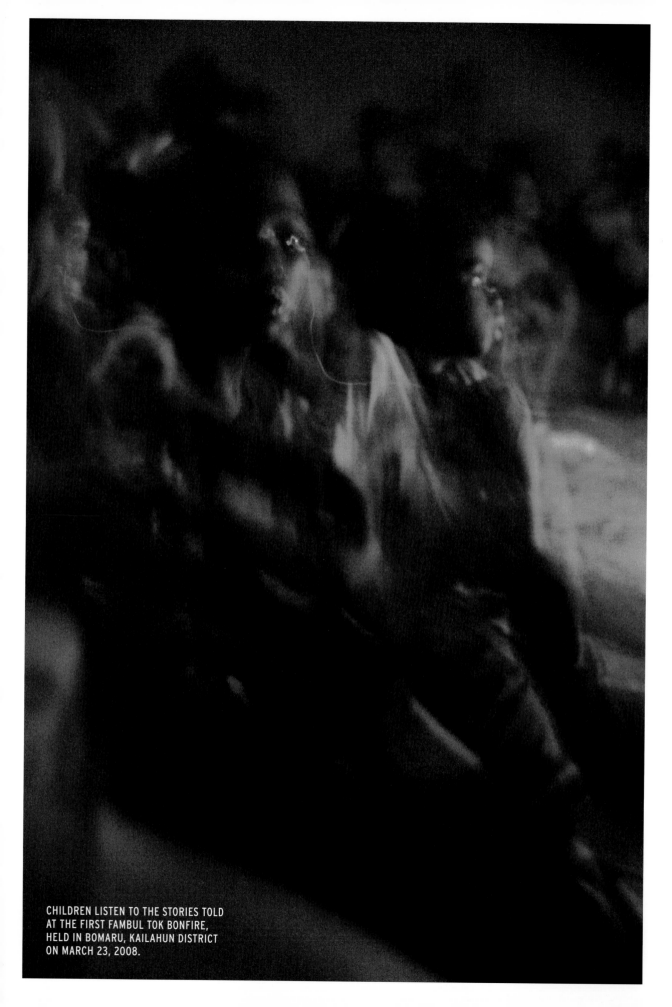

CHILDREN LISTEN TO THE STORIES TOLD
AT THE FIRST FAMBUL TOK BONFIRE,
HELD IN BOMARU, KAILAHUN DISTRICT
ON MARCH 23, 2008.

TABLE OF CONTENTS

VILLAGE SCENE, SIERRA LEONE.

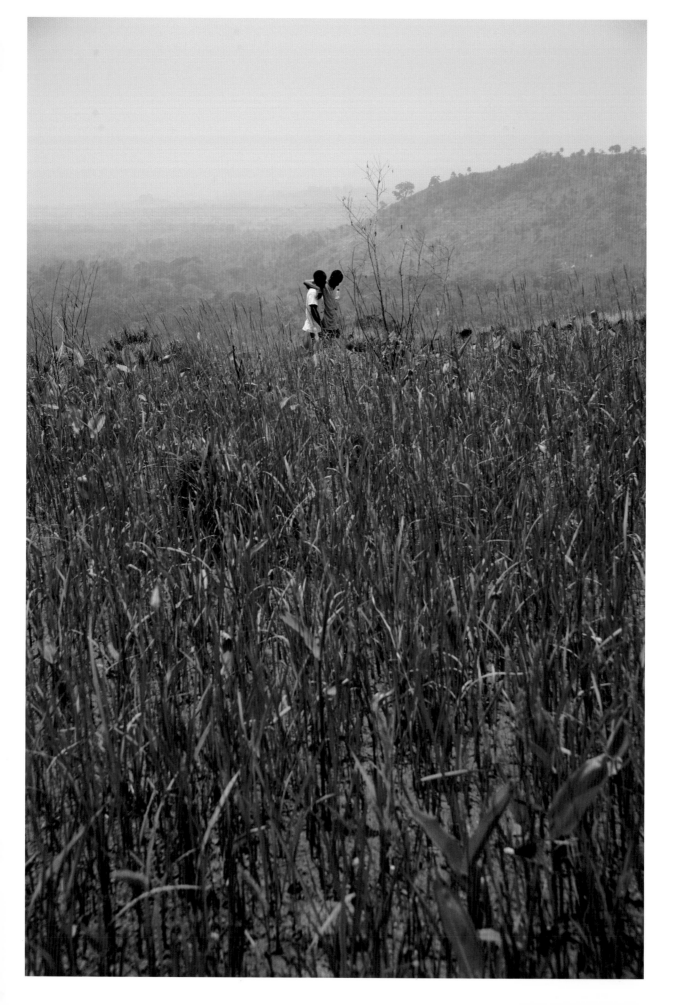

ISHMAEL BEAH

Writer, advocate, and author of the acclaimed book, *A Long Way Gone: Memoirs of a Boy Soldier*, he was born in Sierra Leone in 1980, and at thirteen was forced to become a child soldier. He lives in New York and works to help former child soldiers repatriate in their communities.

I remember the gatherings in Kabati, my grandmother's village, when I was a boy. This was many years before the war. It was always at night under the moonlight, or at those times when the sky was heavily painted with darkness, a kerosene lamp was hung either in the low branches of a mango tree or placed in a metal tray that sat on top of a mortar. If kerosene was scarce, fire was made with piles of wood. Men and women would walk to the village square from their farms or places of work and slowly settle their bodies either on the ground, wooden benches or logs. Children would follow behind their parents and grandparents and sit on straw mats among the adults. Once everyone was seated in a circle around whatever the source of light was, the elders introduced the case at hand. They invited the person who had made the complaint to explain their side of the story and after he or she was done, the accused was asked to recount their version of the same event. Each side was heard with no interruptions—except when it was necessary to clarify some facts. Afterward, witnesses were called upon to speak. The elders then summarized what they had heard for the benefit of everyone and they began to deliberate over the case. One elder would bring up certain points and another would argue against it or voice their support, and then the gathering will be consulted. This went on until they reached a consensus verdict about who was wrong.

At all of such hearings that I attended with my grandmother and grandfather, there were never punitive measures proclaimed against the guilty. Some of the punishments were brushing the path to the village, or from the village to the river, helping the person who had been wronged with the fixing of their thatch roof house, brushing the cemetery and cleaning all the tombstones etc. In general the punishment was always something that benefitted the community or the person wronged and simultaneously assured the guilty that they still had a responsibility and commitment to their community. The guilty was also asked to publicly ask for forgiveness not only from the person they had hurt or wronged but from all the people, for disrupting the order of things in the village.

There was a specific instance wherein a young man's punishment was to help the family he had hurt brush their farm. This meant he had to spend over a week with the family from dawn until dusk, walking with them on the dew-soaked path to the farm, resting under the same shade, drinking from the same gourd of water when they rested from the brushing, and eating from the same plate or bowl when food was served at midday and at the end of the work day. The idea was that during the course of this punishment, the relationship between the young man and the family he had hurt would

be repaired. The punishment therefore was one that facilitated a rehabilitative process, a genuine strengthening and repairing of the community so as to avoid the same thing from reoccurring.

These were very sophisticated initiatives that occurred in different parts of my country Sierra Leone before the war that started in 1991 that destabilized the country and brought about bloodshed, distrust, and enmity between people who had lived together. A culture where, once upon a time, a child would not raise their voice to anyone older than themselves became a place where that same child, under duress, would shoot and kill an elder. As a result of such things and many violent acts that occurred during the war, people were uprooted from their land, homes, life, culture. They came to disbelieve in their own capacity to have a meaningful contribution to their own lives. As a nation, we had mislaid the strengths and tremendous resilience and traditions we had to heal and repair our communities.

I believe that the reawakening of our own measures and traditions to facilitate our holistic recovery from the war has begun with Fambul Tok (krio for "Family Talk"). Through this initiative, one that is wholly ours, we Sierra Leoneans do not only begin to repair the foundations of our traditions that kept us together as a nation, as a family, but we also rekindle the wisdom of our past before the war that would serve as an antidote to nourish our hearts and minds, bind our wounds, and prevent us from ever revisiting the days when those unnatural sounds of guns reigned over our beloved land. This book will introduce you to the remarkable spirit of my people, the spirit that was dulled by the war— but is starting to brighten again, in hope and belief in our future.

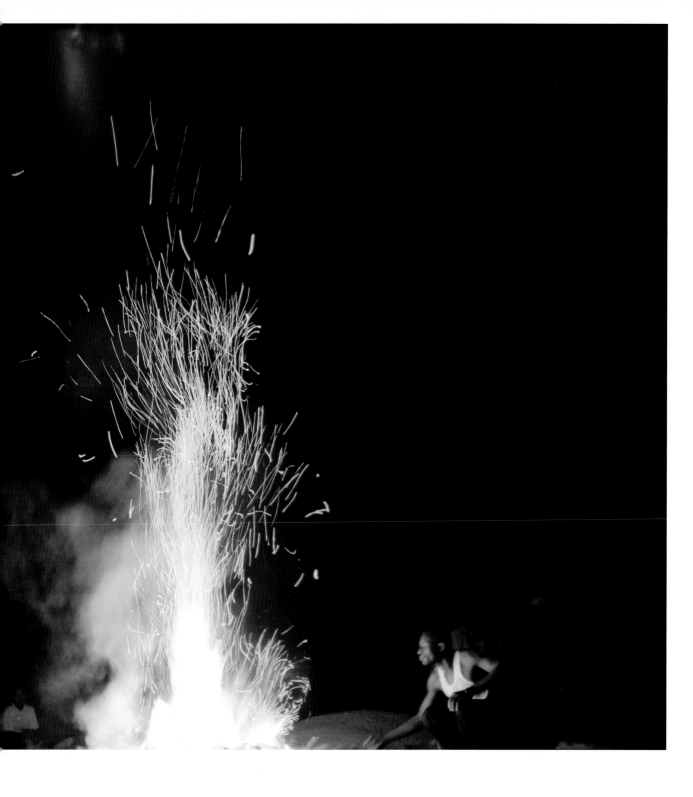

PREVIOUS PAGE: NYUMAH (RIGHT) WALKS HOME
WITH SAHR, AFTER ASKING FOR HIS FORGIVENESS AT
A BONFIRE CEREMONY A FEW DAYS EARLIER. REBEL
FORCES HAD FORCED NYUMAH TO BEAT SAHR SO
SEVERELY THAT HE CRIPPLED HIM, AND TO THEN
KILL SAHR'S FATHER.

STOKING A BONFIRE IN FAIMA, KONO DISTRICT.

PRE-BONFIRE CEREMONY IN BULOWMA, KAILAHUN DISTRICT.

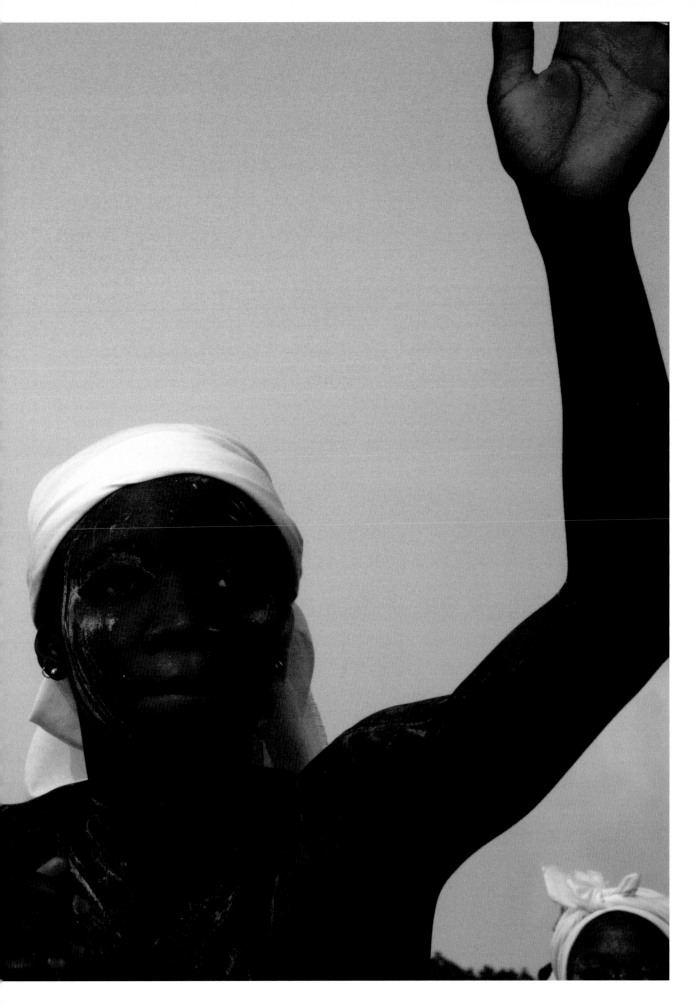

THE VISION FOR FAMBUL TOK: INTERVIEW WITH JOHN CAULKER

Executive Director of Fambul Tok International, and a longtime human rights activist in his native Sierra Leone, he founded Forum of Conscience and was chairman of Sierra Leone's Truth and Reconciliation Commission (TRC) Working Group.

John Caulker first became a human rights activist during the initial years of the war in Sierra Leone, before founding the human rights NGO Forum of Conscience in 1996. Risking his life to document wartime atrocities, he infiltrated rebel camps, disguised, to gather information that he would then pass along to international organizations such as Amnesty International, Human Rights Watch, and Article 19. As the national chairman of the Truth and Reconciliation Commission (TRC) Working Group, Caulker pressured the government of Sierra Leone to implement the recommendations of the TRC's 2004 report, recommending revenue from the sale of Sierra Leone's natural resources benefit a special fund for war victims. To this end, Caulker also mediated an agreement that allowed members of the Amputees and War Wounded Association to participate in the TRC and Special Court process. He served as one of the two civil society representatives on the National Reparations Steering Committee, a delegation that oversees the implementation of the reparations program in Sierra Leone. A Human Rights Fellow at New York's Columbia University Center for the Study of Human Rights in 2007, he founded Fambul Tok in partnership with Libby Hoffman and Catalyst for Peace in 2007. The story of John Caulker, and thus of Fambul Tok, begins here in 1998, after the government was reconstituted following exile in Guinea during the eleven-year civil war.

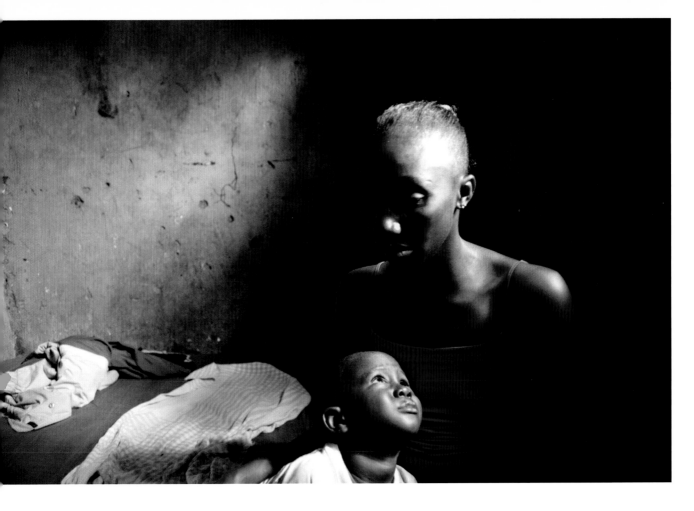

During the war we identified human rights violations and reported to Amnesty International, and they, in turn, would issue press statements. They were very careful not to mention the source of the information, keeping our identity unknown. Yet I realized it would make a huge difference if we spoke for ourselves; for the voice within Sierra Leone. Instead of just issuing a statement from London, we were determined to issue a statement from Sierra Leone that would tell the world what was happening here. That's how we came to establish Forum of Conscience.

There were a lot of human rights atrocities evident at the time and they were not very well handled. The democratically-elected government of my country was not morally positioned to judge others. Why? Because all the players had blood on their hands. The situation could be described as a 'fog of lies,' because no one really knew who had committed which specific abuses during the attacks on the villages. You see, they all dressed alike, the rebel group (the Revolutionary United Front, or RUF), the local civil defense forces (also known as Ka-

marjors and *donso*, or local hunters) who tried to protect their community, even Executive Outcome (or EO, the South African security agency hired to help defeat the RUF) forces supported by the government—they all became very violent and committed atrocities. All these groups wore similar clothing —just shirts with combat trousers or jeans—so it was hard to tell them apart.

With the aftermath of the conflict came the trials of some of those deemed responsible. I objected to the idea of the trials and suggested instead a Truth and Reconciliation Commission (TRC). I almost lost my life because of that suggestion, realizing if you speak the truth it isn't always comfortable. The rebels didn't like it, saying it favored the government, and the government opposed it as well, labeling me as a rebel sympathizer bent on revenge on those who had moved out of the country.

I should explain that when the 1997 coup happened, those who had money, those who could, immediately left. On that Monday the banks were closed, and they stayed that way for nine months. Those with

families or parents abroad were sometimes able to escape, yet hundreds lost their lives trying. It was in this period that I was actively reporting to Amnesty and other human rights organizations.

Then-president Kabbah said on the BBC that he would come back to rule at all costs, "In order to protect democracy," and under his orders the West African military group ECOMOG started bombing targets indiscriminately, including innocent civilians (though they said they targeted military bases only).

When the government finally returned from exile, the reprisals started against the rebel groups. Twenty-four senior soldiers were executed, an event that fueled their anger and immediately led to renewed conflict. These soldiers had their troops, all loyal to them, who thought they were wrongfully executed. The boys went into the bush and then came back to Freetown in 1999.

Ahead of the January 6 rebel attack on Freetown, the United Nations Office of the High Commissioner for Human Rights in Geneva asked the Human Rights Unit within the UN in Sierra Leone to evacuate me and my family to Guinea, because my statements on national radio were being misunderstood and I was being interpreted alternatively as both a government and rebel sympathizer. Meanwhile, in January 1999, the war escalated in Freetown. The city had never before received an attack but now, burning houses and killing people seemed commonplace. Fairly suddenly, the UN left.

While in exile in Conakry I coordinated a human rights committee that sent a message to President Kabbah asking him to consider the idea of a Truth,

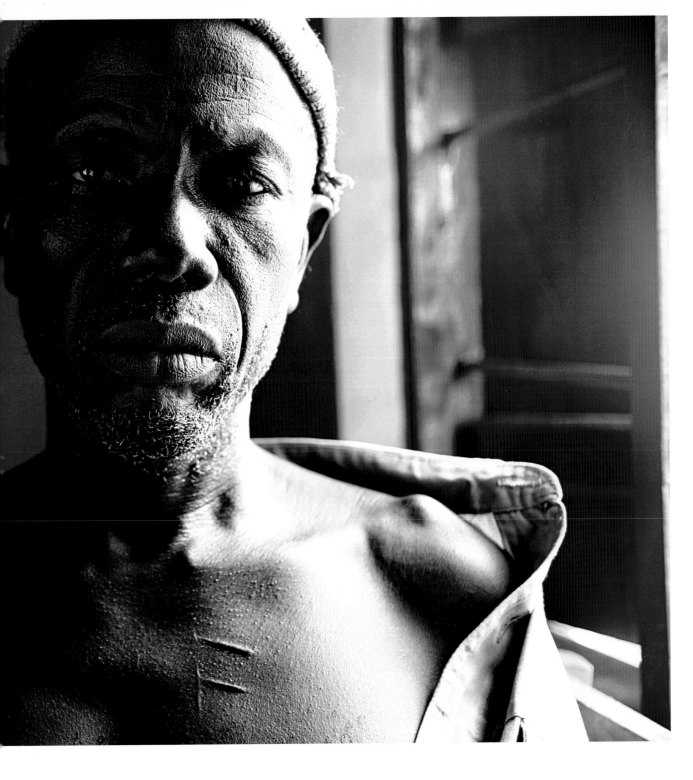

PREVIOUS PAGES: (TOP) YOUNG MOTHER
AND CHILD.
(BOTTOM) PHOTOS IN A SMALL
MUSEUM SET UP AS A MEMORIAL
TO VICTIMS OF A MASSACRE IN
TOMBODU, KONO DISTRICT.

(ABOVE) MAN CAPTURED DURING THE WAR
BY THE REBEL REVOLUTIONARY UNITED
FRONT, SHOWS THE "RUF" LETTERS THAT
WERE TATTOOED ON HIS CHEST BY HIS
CAPTORS.

PEACE COMES WHEN WE REALLY ACKNOWLEDGE WHAT WENT WRONG,
WHEN WE REALLY RESTORE THE DIGNITY OF VICTIMS, WHEN OFFENDERS
HAVE THE OPPORTUNITY TO EXPLAIN WHY THEY COMMITTED THE
ATROCITIES THEY DID, AND TO APOLOGIZE. THEN ONE COULD SAY WE
ARE AT THE BEGINNING OF THE LONG ROAD TO PEACE.

-JOHN CAULKER

HOMES DESTROYED DURING THE WAR STILL STAND
THROUGHOUT THE COUNTRYSIDE, LIKE THIS ONE IN
KOINDU TOWN IN KAILAHUN DISTRICT, REMINDERS
OF THE CONFLICT'S DEVASTATION.

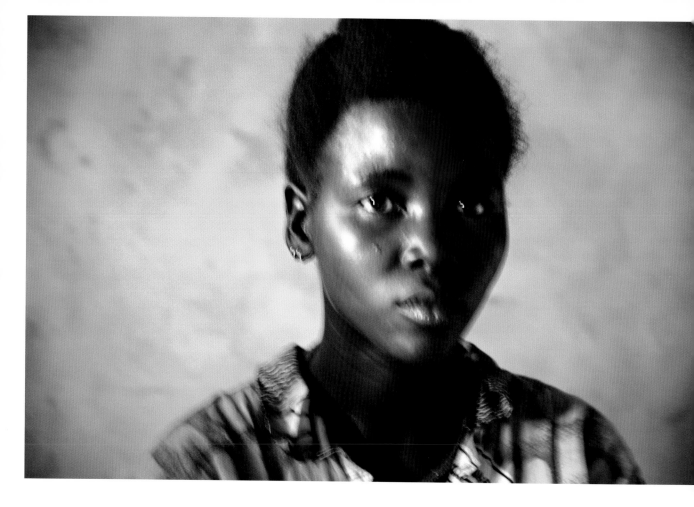

Justice, and Reconciliation Commission—this was the official document that started that process. I advocated a commission that would encourage people to apply for amnesty, urging them to speak the truth and request amnesty for what they did in exchange for their truth-telling. But I also suggested that if you don't say the whole truth they can prosecute you. I urged this instead of simply having a blanket amnesty, but in the end that didn't prevail.

About three months later, I returned to Sierra Leone and talked with my colleagues in civil society. The government and the rebels were engaging in negotiations that culminated in signing a peace accord on July 7, 1999, in Lomé, Togo. In collaboration with Article 19, Forum of Conscience issued a statement calling on the parties in the negotiations not to resort to quick-fix power sharing, asking them for better ways to address our complex problems. We had learned that the head of the RUF was to be appointed to a position equivalent to that of Vice President and that he was in charge of all the mineral resources in the country! (That concession was said to be the prerequisite for the peace accord passing, and for the establishment of a TRC.)

We at Forum of Conscience opposed the blanket amnesty agreement that was also a part of the accord. We wanted to challenge it, although my initial thinking was not to go with the Western approach of a standard TRC. My human rights background left me concerned for the people in the rural communities. I wrote a paper in 2001 calling for mini-commissions, which would feed into the official Truth Commission, and stressed the importance of a local dialogue and local ownership. I knew that was the only way people would feel comfortable telling their stories—in their communities rather than traveling to the big towns. I shared the paper with the architect of the Truth and Reconciliation Commission, but the idea was dismissed, on the grounds that nothing like that had ever happened before.

(TOP) A GIRL WHO WAS ABDUCTED BY REBEL FORCES DURING THE WAR AND FORCED TO SERVE WITH THEM.

(OPPOSITE) KOIDU TOWN, THE CAPITAL OF KONO DISTRICT, THE HEART OF SIERRA LEONE'S DIAMOND MINING TRADE AND THE SITE OF SOME OF THE WAR'S MOST FEROCIOUS BATTLES AS ALL SIDES FOUGHT FOR CONTROL OF THE DIAMOND MINES.

Meanwhile, the Sierra Leone Bar Association discussed the possibility of challenging the amnesty agreement in the courts, alleging that it did not address impunity. The people, though, wanted peace at any cost. There was jubilation across the country that the war was over. As a result, Forum of Conscience decided not to challenge the amnesty in court, thinking it might be (political) suicide since the masses supported it.

Instead, my colleagues and I within civil society decided to look more deeply at the peace agreement to identify relevant sections that addressed human rights, so that we could focus our efforts on advocacy for implementing them well. I became the head of the TRC Working Group, a consortium comprised of some sixty NGOs who lead the discussions before, during, and after the Truth Commission. We felt there were gaps in the process, and we worked to have them addressed. The grassroots communities were not fully consulted as part of the discussions, and the handling of the issue of community/

people's ownership of the process was questionable. In the absence of the full participation of communities, the peace process was very fragile.

I nevertheless worked to make the TRC process more inclusive. The amputees and war wounded groups had refused to participate in the TRC and the Special Court on the basis that they felt they were being used as a spectacle. When then-US Secretary of State Madeleine Albright and other foreign dignitaries came to the country, they were taken to where the amputees lived to generate sympathy and resources, but at the end of the war not much was done directly for the amputees. Ex-combatants were rewarded for fighting, but the amputees and war wounded felt they were ignored.

So they wanted something on the table before they would cooperate with the TRC and the Special Court. When the new Executive Secretary of the TRC, and now-Sierra Leonean Minister of Justice, Frank Kargbo, was first sworn in, I had a strained

relationship with the TRC, because of my strong advocacy for making the process more inclusive of those in the most rural communities. But immediately after his swearing in, he came straight to my office and asked for my help bringing the amputees on board with the TRC process, pleading for me to rise above my concerns and support the larger interest of the country. "We are all Sierra Leoneans, we have to work together," he said. I agreed to help, and after a week of negotiations, I was able to bring the amputees on board, emphasizing that the TRC could not include recommendations that addressed their needs without their input and participation. I was also able to successfully advocate that the TRC process employ amputees, and not only the able-bodied, as statement takers in their work.

During the eighteen months of the Commission, I developed increasingly strained relations with them. I was raising uncomfortable issues constantly, even over relatively small things, like printing the report: why print it outside Sierra Leone when you can print it in-country and provide employment to nationals? Why not focus the efforts of the TRC at the local level? Why make victims travel on their own, without the support of their family? The TRC was certainly a worthy research project, and its report was good—but the process was less so. The fundamental problem was with that process—the ownership was not with the communities. It was being treated more as a UNHCR project than a project owned by Sierra Leoneans.

The TRC had hearings and issued a report with recommendations, and that was it. Done. To think that it could achieve sustainable peace, driven by internationals, was far-fetched. To do that, you need Sierra Leoneans at the forefront to drive the process and to be frank, I think that was a lost opportunity.

The TRC had made a recommendation ninety days after handing the report to the President, suggesting a reparations fund be established for the war wounded. Nine months later, nothing had been

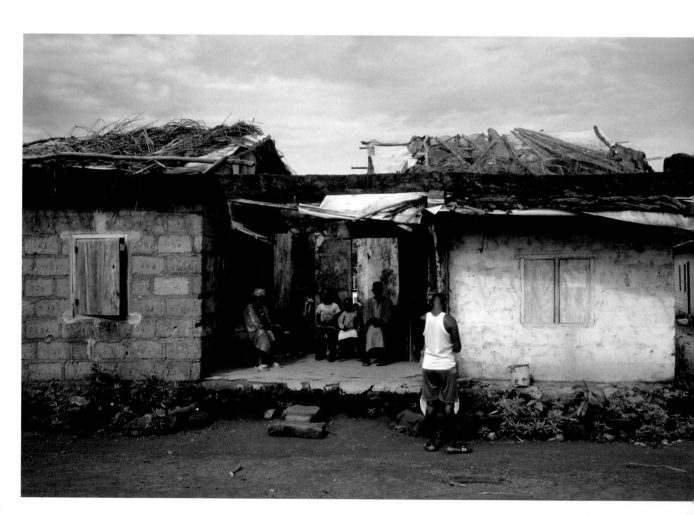

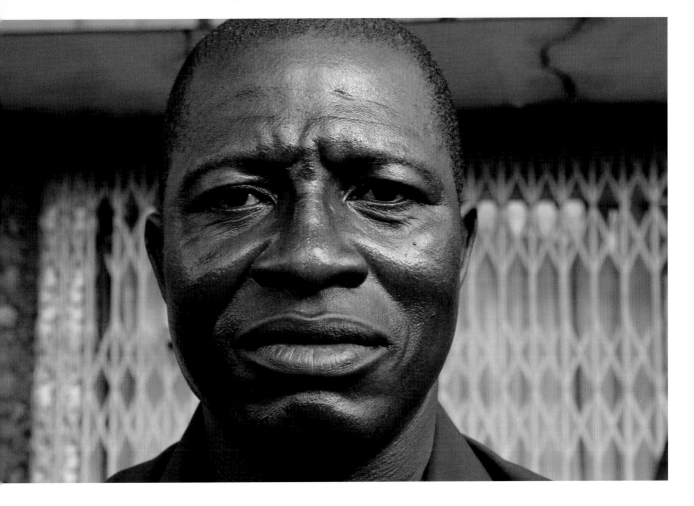

done. I needed to save face. I teamed up with the amputees and war wounded again to help organize them, and to get them to speak for themselves. We organized regionally and nationally before we engaged the government, building bodies of support all the way down to the villages.

Even with all that, however, the Kabbah government refused to implement the reparations recommendation. It wasn't until 2007 that the government finally began to discuss the reparations process.

The TRC recommendations also called for the President to apologize to women for crimes committed against them and for all the suffering they went through during the war. Again, the government was not eager to implement these recommendations and to apologize. They were worried they would be indicted by the Special Court.

The Special Court is a hybrid, set up through the Office of Legal Affairs by the international community, with a mandate to try those who bore the greatest responsibility for the conflict. After five years of operation, they've indicted thirteen people and tried nine or ten people (two have died and one is at large), spending hundreds of millions of dollars to do so. Yet, even with all that, it hasn't responded to the needs of the people and there's no provision for victims. Initially, as a human rights advocate, I thought the court was a good idea, but we at the Forum of Conscience wanted them to work through and improve on the national court system and receive fair trials through that venue, so a legacy would be established. That didn't happen, however, as the court became more of an international tribunal, with limited national accountability.

At this point I was really frustrated and burnt out, suffering from low energy. I accepted a human

(TOP) TAMBA NGAUJAH, THE FIRST AMPUTEE OF THE WAR IN SIERRA LEONE.

(OPPOSITE) MANY FAMILIES, INCLUDING THIS ONE, LIVE IN BUILDINGS THAT HAVE BEEN ONLY PARTIALLY RESTORED.

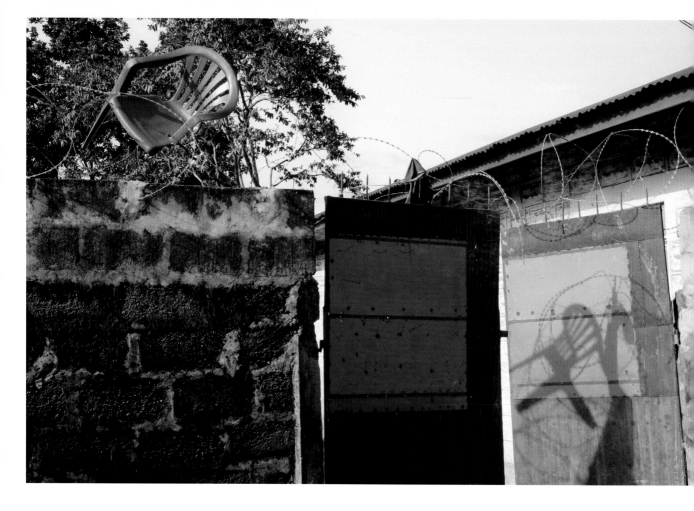

rights fellowship at Columbia University, in New York, in order to step out of the country, get perspective, and decide my future.

THE BEGINNINGS OF FAMBUL TOK

I badly needed a break, and turned down requests for meetings and appointments a number of times. Then in the office one day, my colleagues said someone named Sara Terry was here to see me. My colleagues thought I shouldn't bother talking with her, describing her shoes (they were those plastic shoes, Crocs), that they thought didn't make her look like a professional. In the end, though, I decided to go ahead with the meeting. Sara was there working on stories of reconciliation in Africa with the foundation Catalyst for Peace. She said to me that day that she thought people in Sierra Leone were quick to forgive and I disagreed. I said, "No. From the outside it's easy to think so but deep down

there are issues we need to address, both individually and as a community." I described to her my vision for a grassroots process. She said it was a great idea, and that she would contact interested people. Two weeks later she said, "I talked to someone who is very interested," referring to Libby Hoffman and Catalyst for Peace. A further two weeks after that I came to the US for my fellowship at Columbia. That's when I met with Libby. Our first phone conversation lasted for two hours. We then met in person for a day, and after that we decided immediately to work together on the program that became Fambul Tok. She helped shape and design my vision. I asked if she thought it was achievable and her answer was emphatically, "Yes." I then returned to Sierra Leone in December, 2007 to begin implementing the program.

Fambul Tok has grown greatly from these modest beginnings. We have learned that while it was born

(TOP) BARBED WIRE AND HEAVY GATES PROTECT A COMPOUND IN KENEMA, WHERE MANY TRADERS BUY AND SELL DIAMONDS.

(OPPOSITE) MAN WHO WAS CAPTURED BY REBEL FORCES DURING THE WAR.

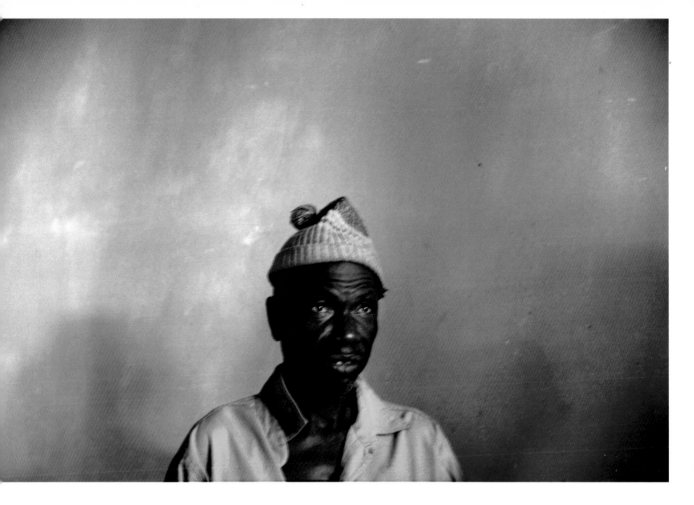

here, the approach is international—the importance of consulting people on issues that affect their lives is central to human experience. The respect this implies, that recognition that the people most impacted by a conflict are the ones who know best about their needs, is absent in most conflict resolution situations. The outside experts go in saying they have the answers—telling the people what to do. The locals are compromised, their work damaged. One example might be the importance of looking at those in refugee camps with dignity. They're not just people who have lost all their hope—they have value that you must connect with. To find the right solutions, it's necessary to engage closely with them. You may initiate the conversation, but the answers are all there and they will emerge naturally.

Most of this approach we are discussing has to do with individuals, not policy, even though policy can still be changed. Fambul Tok has made it clear that when the international community comes into a country they should first listen and, in an ideal situation, they should work their area of intervention from the inside out. Instead, most international NGOs come with a pre-set agenda. Respect cuts across many lines.

We are hopeful that the international community, the NGO community, and the Sierra Leonean government will all learn from the approach of Fambul Tok—that working with the community doesn't mean coming with a checklist but rather coming with an open mind and engaging the community. You have to work with people and see through their own lens how they see things, not come watching through your own prism from the outside. It's always important to see things from the African context, and from the specific national context.

Coming from the Western world, for example, you

are tempted to cry in dismay, "How do people live in this country? How do they live without clean drinking water, without a health center?" If you come with the feeling that what you see is just poverty and want, then you are wrong. If you really work with people and look at how we see things, we see that the community is in many ways healthy and alive, that they are rich in their sense of culture and they have something of real value there. If you work with the people to bring out that value, you will find a very different outcome.

In Fambul Tok, the people organize the programs. When you allow people to lead the reconciliation process themselves, that process becomes more sustainable. Let them own the process, and they will never let go easily. We do not go to a community with promises. We are careful not to be seen as NGOs going in with aid handouts. We are very clear we have no money to give—we are here to work with the communities on their terms. In our programs the community contributes a significant amount of what is used for the ceremony; they are doing it for themselves. The willingness of community members to volunteer their services is an indicator of how much they value the process.

We go to the rural communities, and our message from the beginning is: we do not have resources to give you, like others. All we try and do is work together; work with you to find your answers. What do *you* want to do? If you want to embark on reconciliation ceremonies, well then, what do you have already to support this process, and how can we work with you? That has been our message. For us, the most important thing is building on ownership. It's very unusual for organizations to come and say, "This is your process." We emphasize that, telling the communities where we're working, "Don't just see yourself as ordinary people. You are not ordinary. You are important citizens, you have tremendous value in yourself." We want them to realize how that value could be used to support the community and ultimately how that value will be transformed in a national process where the country will become whole.

We have found that there is little interest in Western notions of punishment at the community level. You see, punishment is a relative term. You can punish people in different ways. Before the colonial masters came to Africa, there were no prisons here. We have our own way of addressing justice, our own way of punishing people, but it does not involve sending them to prison. Nor do we send them into exile. We know all the people who committed these atrocities are Sierra Leoneans, and that they are part of our resources—our human resources. We can transform them, rehabilitate them to be good citizens and provide them skills to be productive, to help the very communities they destroyed. There is an adage in our local dialect that says, "There is no bad bush to throw away a bad child." A child is a child. We must accept them within the family fold regardless.

Our culture supports this process. Our culture is built around conversation, centered in storytelling, where people sit around the fire to talk about the day's events. Also, part of our tradition is in talking to our ancestors. We believe that our ancestors are all around us, protecting us. If you don't please them, you'll have bad luck. If you appease them, you are bound to have a good harvest. At Fambul Tok the communities have ceremonies that involve invoking the spirit of the ancestors, and asking for their blessing, is a very important part of the reconciliation process. They touch the hearts of the victims because the victims need spiritual support to accept the offenders, and this helps provide that.

There is a long process to our work. Before we have a bonfire we perform outreach in a community for a minimum of three months. We train a reconciliation committee that includes the head of the youth, head of the women ('mommy queens') religious leaders (Christian, Muslim, and traditional elders) in basic counseling skills. Because they stay in the community, they are always there to talk through with offenders as and when the need arises. It takes a lot of time, and a lot of training, to help people feel comfortable to tell their stories and not be afraid. We have a district team that goes in regularly before

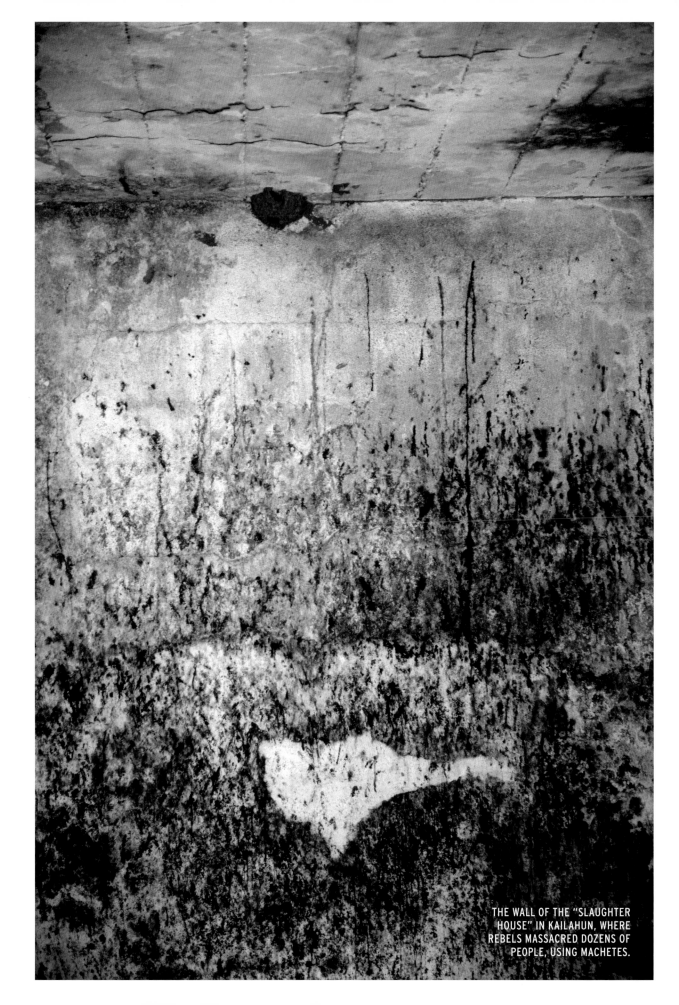

THE WALL OF THE "SLAUGHTER HOUSE" IN KAILAHUN, WHERE REBELS MASSACRED DOZENS OF PEOPLE, USING MACHETES.

and after the bonfire to find out if the victims are ok, if the offenders are ok, if they are healing. It does not happen in a week, or a month. It's a long process.

One offender came forward and acknowledged that he killed someone whose family had never realized he was dead—they thought he was alive in Liberia, or Guinea. When he came forward into the circle and said, 'I am responsible for the death of that young man,' the family broke down into tears. The bonfire was put on hold; we allowed the family to cry. I went to the family, "Now you know your brother is dead, your son is dead, what do you do? You know the person responsible is here, so what do you do?" And do you know what they said? They said, "He is our son," because the person who committed the crime was someone who helped them in the community. They didn't want to kill him for being responsible for the death of their brother; they didn't want revenge. All they wanted was to mourn, to have a ceremony for the deceased because they had thought he was still alive. The offender volunteered to help them for the rest of his life. He said he would help in farming or domestic work—whatever they wanted. They could always call on him. He said he was willing to do that, to make amends for his act.

There were two instances where a woman who had been gang-raped came forward and refused to shake hands with the perpetrator at a bonfire. The following day, when the community engaged them and talked with her, she accepted the apology. What is important to learn from the process is that she said she wanted every detail to come out, so when they first had the discussion she complained, "The time is not enough."

The time is fluid, controlled by the community. So if a lot of people want to tell their stories, the follow-up goes on for days, but it happens then after the bonfire at the peace tree. And these issues get resolved under the peace tree over time. In this case the woman was happy she had that space and time and could say all she needed to say. Her aggressor showed remorse and he agreed to support her, to make reparations.

The reconciliation process actually starts with the bonfire—here the confession and the testimony occur. After that, following the cleansing and libation, there is serious work to be done by the community to support both the victims and offenders, who have gone through the ordeal of telling their stories for the first time in public, and coming to terms with what went wrong. Most times the offenders understand clearly and therefore don't expect to be fully forgiven immediately. It's a process. That's why some of the offenders offer to work on farms and community projects so that over time they will be forgiven, by both their victims and the community.

As Sierra Leoneans we live alongside those who amputated our arms, walk on the same footpath to get water with someone who killed our parents, nearby someone who burned down our house. What greater goodness can you describe than our willingness to forgive each other? It's part of Sierra Leone to be generous, to accept one another. We used to describe ourselves as one big family. "The family tree will bend but never break," as we say here. In Fambul Tok, family isn't merely the biological family, but the community as family, the district as family, and even the nation as family.

But the difference between conflict and peace is a thin line. From the international community's viewpoint, they say Sierra Leone had peace once the war ended. If you talk to the average Sierra Leonean in the village, however, they say what they want is a sustainable peace. They understand that the conflict doesn't end when the guns are silent. Peace comes when we really acknowledge what went wrong, when we really restore the dignity of victims, when offenders have the opportunity to explain why they committed the atrocities they did, and to apologize. Then one could say we are at the beginning of the long road to peace. It is also important to note that peace is personal—it has very much to do with the individual. This is the kind of peace that Fambul Tok is creating a space to support.

We couldn't achieve that peace as individuals before. Because of the blanket amnesty, victims were powerless, even afraid, to confront aggres-

sors. In the secure environment that Fambul Tok helps create they can accuse their attackers, and the perpetrator can answer and consequently explain why. What is their answer? Maybe it was an act of revenge, maybe his commander forced him. It's important that this come out. And even with all the huge work we put into preparing a Fambul Tok, we cannot say who will come forward. We just have to wait and see. The process is very clear that we don't force anyone—they have to come forward willingly; they have to believe in the concept.

I would call the Fambul Tok bonfire the sacred space in the sense that it's only within that circle, within that bonfire that you can say anything you want related to the war. You can call on anyone who did something bad to you, regardless of his or her status, even a chief or a minister. Once you are in that sacred space you feel empowered, because you know the community is behind you and whatever you say, as long as it's the truth, the community will support you. It's also the same for offenders, knowing very well they will not be prosecuted; it's a space for them to honestly speak out the truth. There they can discuss what went wrong, and be able to have a dialogue with the victim, within that exchange of, "Yes, I did this to you, but I'm sorry."

That apology is essential; it is central. For people to acknowledge their deed is the basis for reconciliation. It is a universal truth.

Of course there have been times when people were mistrusted in their apology or when someone was unwilling to forgive. I am human and at times think this myself as I listen to their stories. How can they manage to forgive what seems unforgivable? If the architect of the war comes forward and asks for forgiveness, is this someone who deserves forgiveness? It's not easy, and I think the answer is complex: yes—and no.

I emphasize that it is not a free ride; it is a very difficult ride. It's a very hard moment for offenders to come forward and publicly say what they've done. They knew they committed these atrocities but they've never talked about it openly, and to come

out and say, "Yes, I did this" in front of everyone, to me that's a form of justice, and it shows you believe in the process. Naming and shaming in our culture is very serious punishment. Coming into the middle of his community and acknowledging his crime is seen as punishing the offender in a very public way. You know you've done this when you come and confess, everybody in the community knows what you did, and in the future you will not want to revert to that same act because you will not want to come into the middle and apologize a second time.

And the bonfires are only the first step on the long road to reconciliation. If perpetrators just confess, apologize, and remain in isolation, it is difficult for people to see them as someone who has shown true remorse. The follow-up activities after the bonfire and cleansing are about the idea of staying together, coming closer to each other as a community to try and support each other over time. This is not automatic, so we also have community farms, peace mothers' groups, football matches, and also the peace tree as follow-up activities where victims and offenders can continue to interact and try to come to terms with what went wrong and how to continue on with their normal lives. In the soccer games they are able to play together—victims and perpetrators—and the people from the community will come around to cheer. That helps bring them together.

We are here to listen to one another. When I look forward to what Fambul Tok will achieve three to five years down this road, I see it helping bring sustainable peace to our doorsteps, to the village, to the townships, to the districts, and to Sierra Leone as a whole. I believe the outcome of Fambul Tok will be a great lesson for the international community in terms of the way it reacts and responds to other post-conflict situations. What we must do is treat individual countries uniquely; we must be mindful of international human rights standards, but never water down our culture in that process. I hope that will be our contribution and legacy.

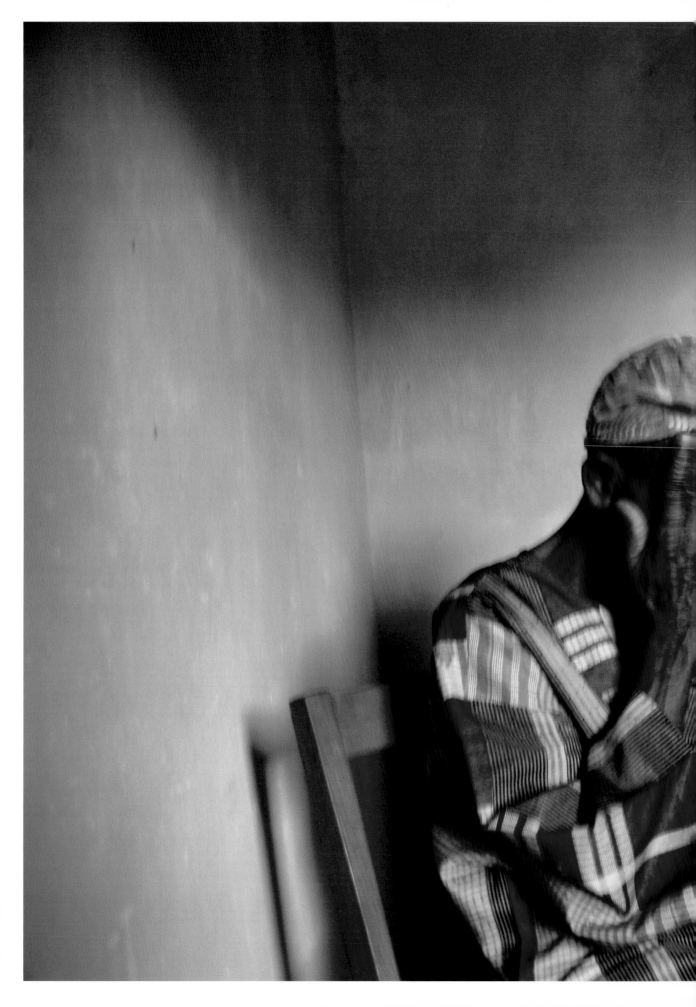

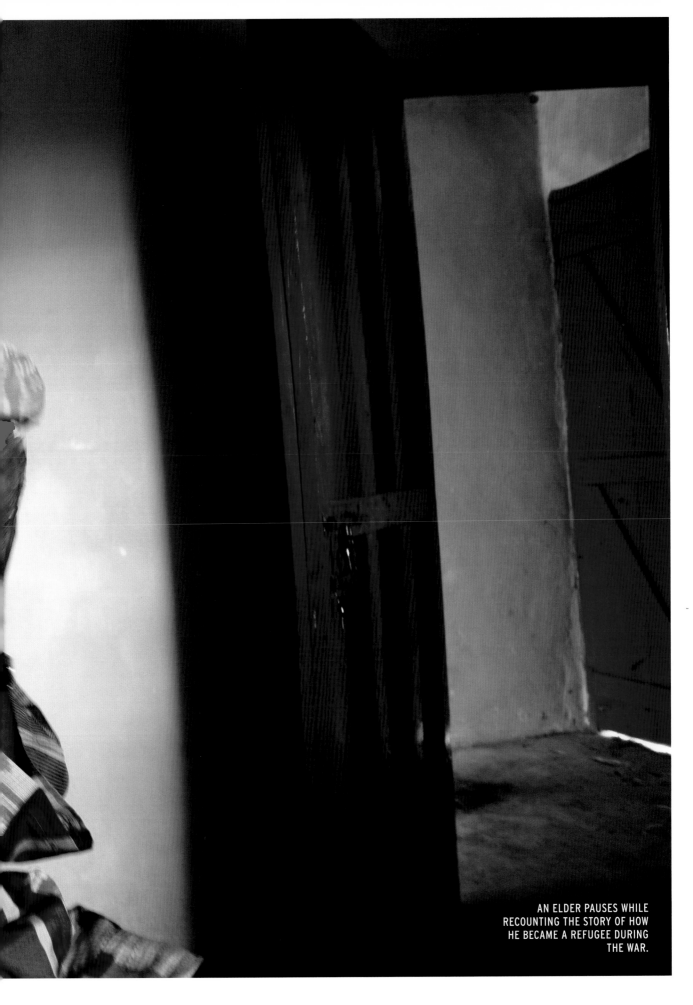

AN ELDER PAUSES WHILE
RECOUNTING THE STORY OF HOW
HE BECAME A REFUGEE DURING
THE WAR.

GRAFITTI, FREETOWN.

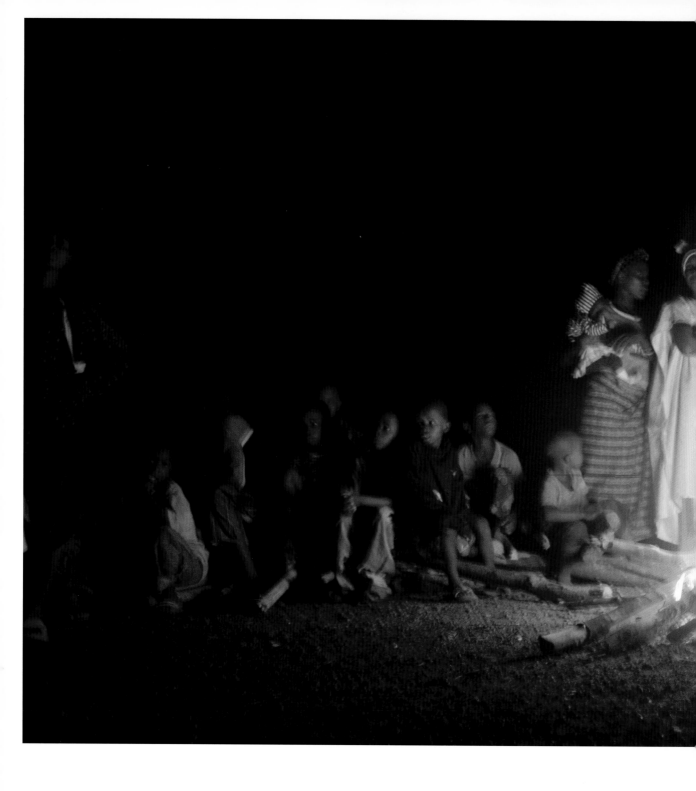

WAITING TO HEAR VICTIMS AND PERPETRATORS
SPEAK AT A BONFIRE CEREMONY IN GBEKELDU,
KAILAHUN DISTRICT.

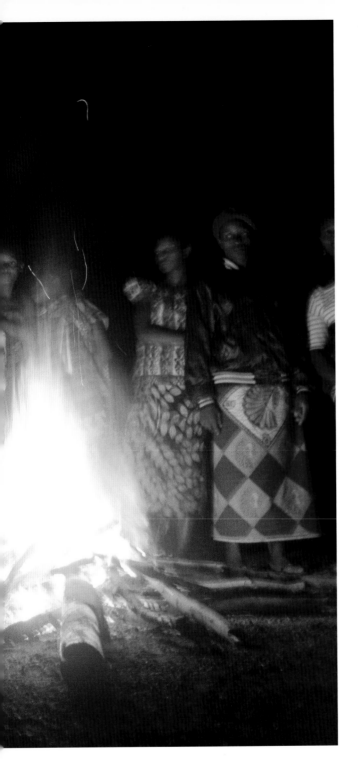

A SEAT AT THE BONFIRE: STORIES FROM FAMBUL TOK'S BEGINNINGS

Producer/Director of *Fambul Tok* (the film), and an award-winning photographer and journalist who focuses on post-conflict issues, Sara Terry founded The Aftermath Project, a non-profit program supporting photographers covering the aftermath of conflict.

The only light is the bonfire.

It's huge, burning with glowing embers and flashing sparks, in the center of a tiny village on the eastern edge of Sierra Leone, just a few kilometers from the border with Liberia. People have come from the surrounding villages scattered around this mountain. Some have walked for miles to be here tonight. As the fire burns, men, women and children sit expectantly on roughly-hewn benches, or on the hard ground, murmuring among themselves, waiting to see who will come forward, who will be the first to tell their tale of a brutal war that still haunts these people, this nation, six years after the violence came to an end.

A young woman gently pushes through the crowd and steps into the light of the fire. She doesn't wait for an introduction; she simply begins to speak. "I was twelve when the war came to this village," she says. All eyes are on her as she continues to tell her story, of how she was captured by groups of rebels and gang-raped.

"There was a man among them that I knew," she says. "He was my uncle." She believed, she remembers, that he would save her. Instead, he joined the

men who'd captured her. "As little as I was," she said, "he had the mind to rape me."

She speaks calmly, without drama, but she is forceful, determined to tell her story. Her uncle, she says, still lives nearby – in fact, he lives next door to her, in a neighboring village. It frightens her to see him each day, she admits. And then she tells the crowd, "That man is here tonight, and I want to bring him forward for you to see him."

There is a stirring in the crowd around the bonfire. People begin speaking to each other, looking to see where the man is – until he is pulled forward into the light of the fire, by the young woman he raped. A village elder says the group will now listen to this man, to hear what he has to say about what took place that day, many years before.

"I was captured by the rebels," he said. "They forced me to do it. I did not mean to harm you." He

feared, he says, for his life. He turns to the young woman and apologizes for what he has done. He asks for mercy, for forgiveness. He bends low to the crowd in front of her.

She hesitates for a moment, and then says, "I forgive you." Her uncle presses her, "Do you really forgive me?" And she answers again, "Yes, I forgive you." Around the bonfire, people begin to clap, then to sing. The young woman joins hands with her uncle, and in the presence of all these witnesses, all these neighbors, they begin to dance, arms swinging side to side. The crowd joins in, celebrating a moment that they believe will lead to healing and wholeness, not just for the two people involved, but for the entire community. It is the first step towards reconciliation.

We too are witnesses, my film crew and I, to the story of Esther and Joseph. It's harder for us to understand what we have just seen – an act of for-

(LEFT) GBEKEDU, IN KAILAHUN DISTRICT, AT DUSK, BEFORE THEIR BONFIRE CEREMONY.

(RIGHT) CROWD AT THE GBEKEDU BONFIRE CEREMONY.

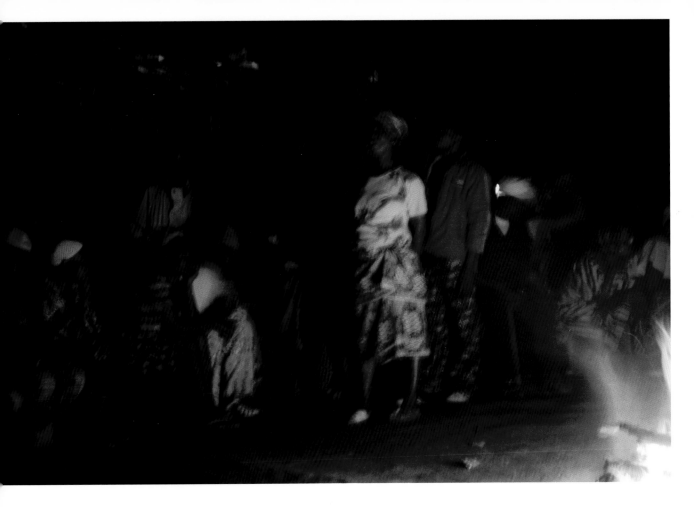

giveness almost unthinkable to the Western mind. But we have come to learn from the people of Sierra Leone, to try to see through their eyes, to explore the depths of a culture that believes that true justice lies in redemption and healing for individuals, and the community and that forgiveness is the surest path to restoring dignity and building strong communities.

What we have seen, and what we will see many, many times in the weeks and months ahead, is a Fambul Tok bonfire – a tradition-based ceremony that is part of a grass-roots program aimed at building sustainable peace, something that Western-based institutions, including a Special Court and a Truth and Reconciliation Commission, failed to do in Sierra Leone. Fambul Tok was started by a Sierra Leonean human rights activist, John Caulker. But it is owned by the people, people like Esther and Joseph, who embrace the idea that peace can only be found through reviving Sierra Leone's culture –

through addressing conflict through conversation, through righting wrongs through personal accountability and forgiveness, through restoring the strength of the community by restoring relationships among individuals.

I met John Caulker in Freetown in 2007, while working with Libby Hoffman and Catalyst for Peace on a project about forgiveness traditions in post-conflict African countries. John had been nurturing a dream of community reconciliation for several years, one based on his culture's tradition of talking through issues, bringing offenders and victims together in the presence of their communities, under the guidance of elders, as a way to resolve conflict. At one point he'd had a little bit of funding to begin building networks at the grass-roots level across the country, working with civil society activists who also longed to see the hard work of reconciliation take root in the villages where unspeakable atrocities had taken place. But the funding ran out – and

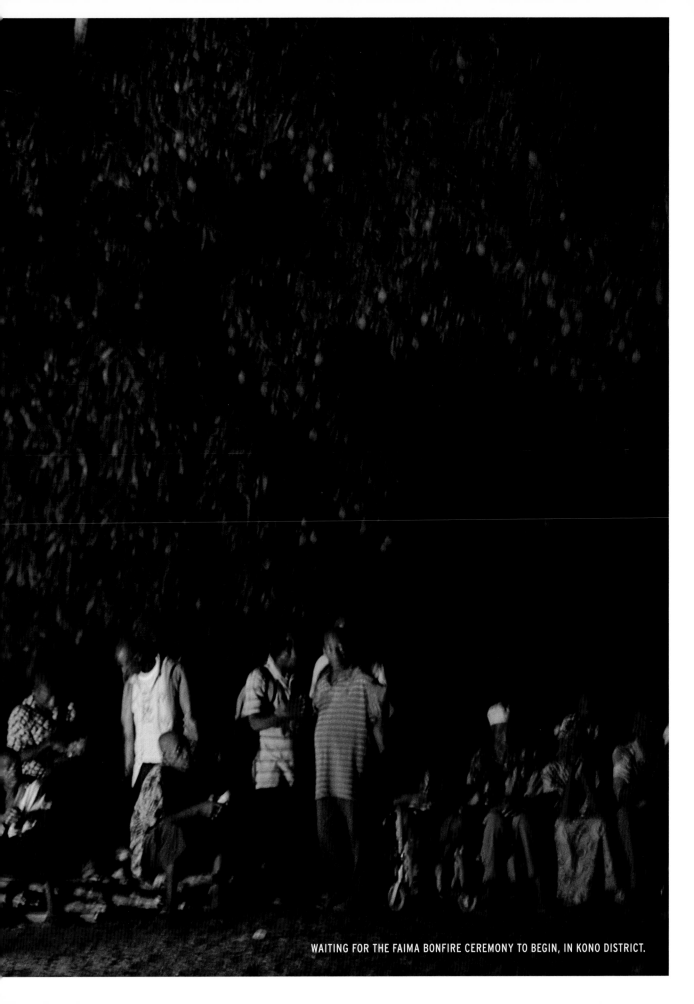
WAITING FOR THE FAIMA BONFIRE CEREMONY TO BEGIN, IN KONO DISTRICT.

despite John's best efforts to find other donors in the international community, he came up empty-handed. The idea had been shelved.

It made perfect sense to introduce John and Libby. Although Libby and I come from different perspectives (her background is in peacebuilding, and mine is in journalism) we had been drawn to work together to explore the lessons of the forgiveness traditions that anchor almost every African nation – traditions that emphasize bringing offenders back into the communities they harmed, to help rehabilitate these individuals so that they can once again become productive members of their villages. Hard concepts for a Western-based mindset to understand – restorative justice over punitive justice, forgiveness instead of vengeance.

I'd first begun to learn about this culture of forgiveness in 2006 when I was working for an international NGO with field offices in Sierra Leone, documenting their work through photography. My driver spoke often of his country's long tradition of peace – and the "insanity" that had come over Sierra Leoneans during the war, a craziness that he said caused people to do things they never would have done during peacetime. His own cousin, a bush hunter from the diamond mining district of Kono, had been the first civilian of the war to suffer what became the commonplace and brutal punishment of having his hands amputated by rebels, who tried to intimidate the local population and the political establishment through gruesome acts of horror. Despite what had been done to him, this man had been among the many Sierra Leoneans who spoke publicly of choosing forgiveness over revenge once the war had ended.

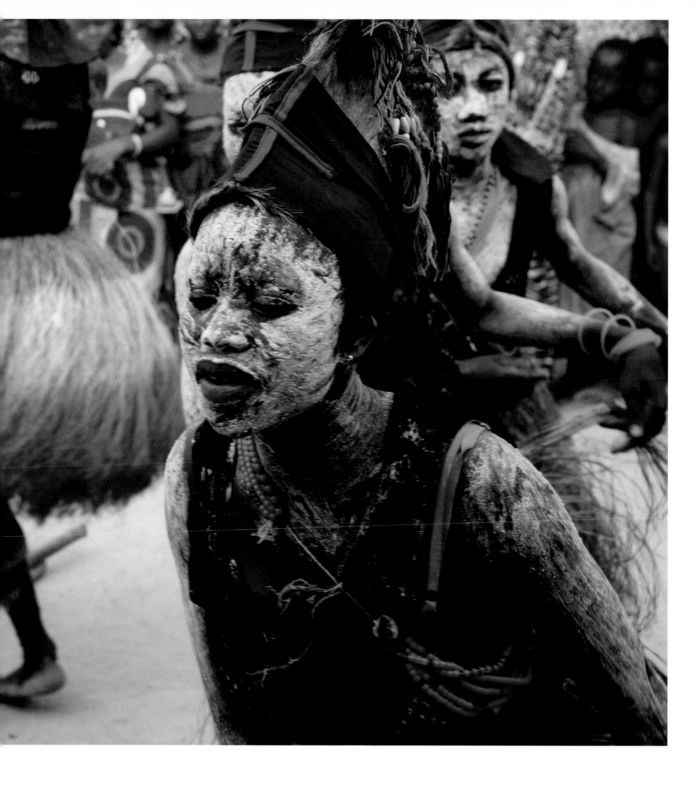

TRADITIONAL DANCES PERFORMED AS PART OF PRE-BONFIRE CEREMONIES
IN KPEINGBAKORDU, KAILAHUN DISTRICT.

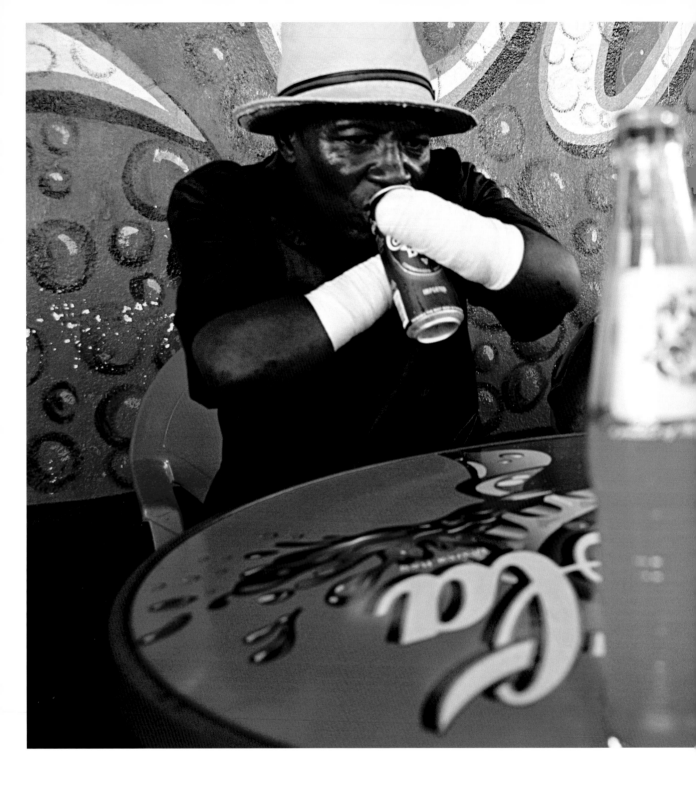

TAMBA NGAUJAH, THE FIRST AMPUTEE OF THE WAR, WITH HIS SON IN FREETOWN.

When I met Tamba Ngaujah on the streets of Freetown, with his handless arms carefully wrapped in clean, white bandages, the war between Lebanon and Israel was raging, the latest cycle in what seems like endless rounds of conflict in the Middle East, fueled in many ways by revenge and cherished grievances. Yet here was this "uneducated" man from one of the poorest countries in the world, who had suffered such a cruel injustice, speaking of why he chose forgiveness over revenge. It was simple, he said: if he took revenge on his offenders (and he knew who they were), then their children, would take revenge on his children, and their grandchildren on his offender's grandchildren...and the violence would never stop.

"And we don't want violence," Ngaujah said. "We want peace."

I was speechless in the face of such wisdom, convinced in that moment that the West had much to learn from Africa. I wanted to find a way to document these traditions in photos and words, but wasn't sure how to move forward. Some months afterwards, on a cold winter afternoon, I shared my thoughts with Libby over a cup of tea in Harvard Square. She, too, had worked in Africa, and was committed to seeing what the Nigerian writer Ben Okri refers to as "the light" in a place so long referred to in the West as the "dark" continent. Our collaboration was born that day, based on a shared conviction that we had much to learn, and also a deep desire to share these stories with others. Which is how I came to be in Sierra Leone again, a year after meeting Ngaujah. By the time I sat down with John in his office in Freetown, I'd learned a lot about the post-conflict situation in his country, spending time with ex-child soldiers, religious men

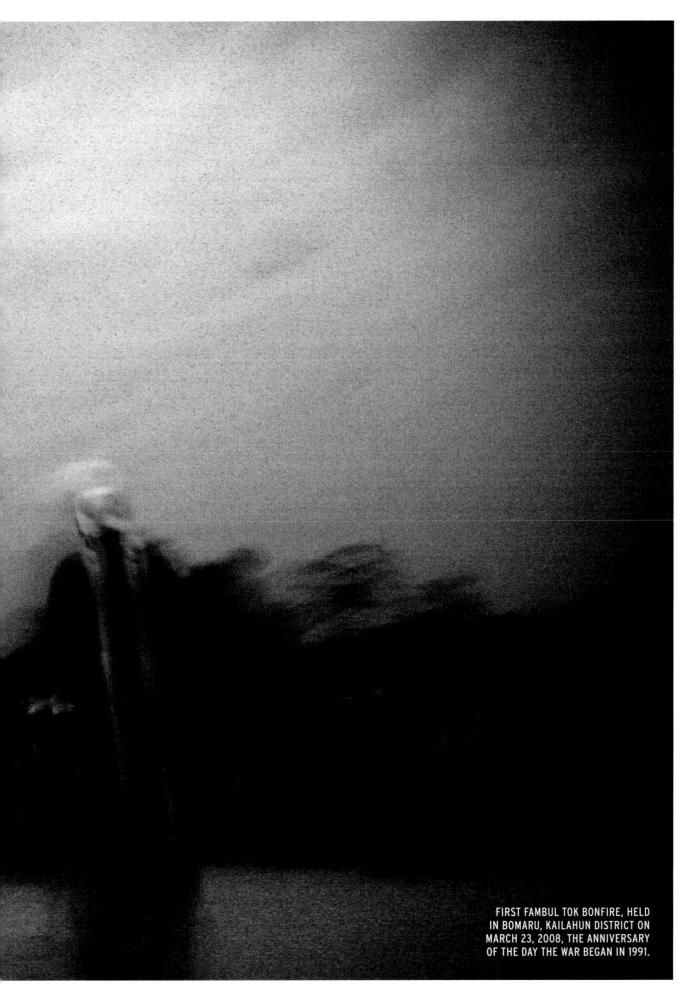

FIRST FAMBUL TOK BONFIRE, HELD
IN BOMARU, KAILAHUN DISTRICT ON
MARCH 23, 2008, THE ANNIVERSARY
OF THE DAY THE WAR BEGAN IN 1991.

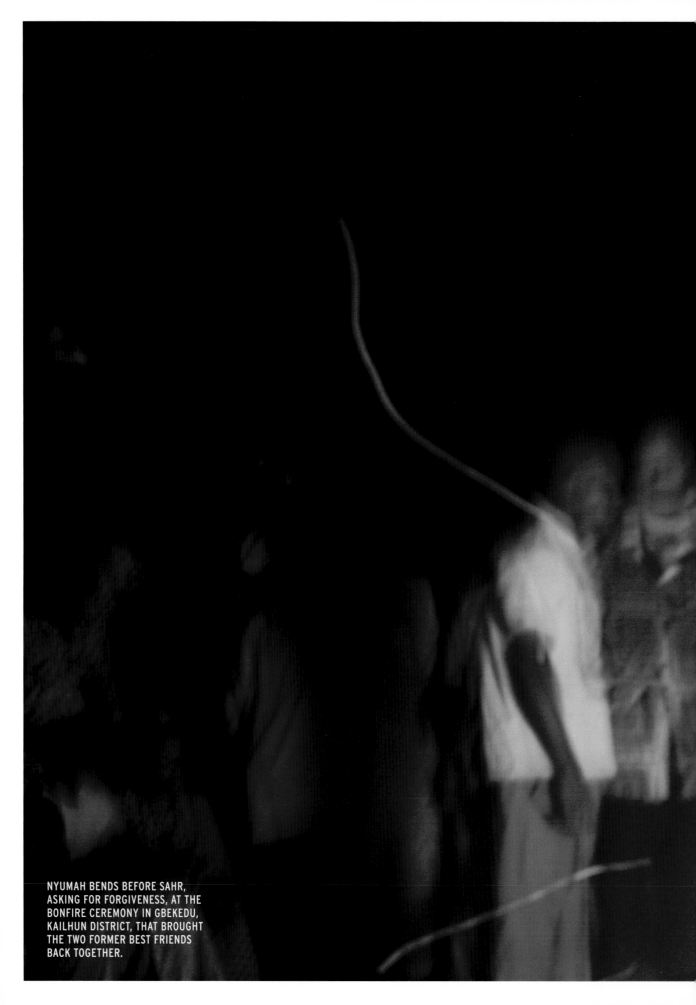

NYUMAH BENDS BEFORE SAHR, ASKING FOR FORGIVENESS, AT THE BONFIRE CEREMONY IN GBEKEDU, KAILHUN DISTRICT, THAT BROUGHT THE TWO FORMER BEST FRIENDS BACK TOGETHER.

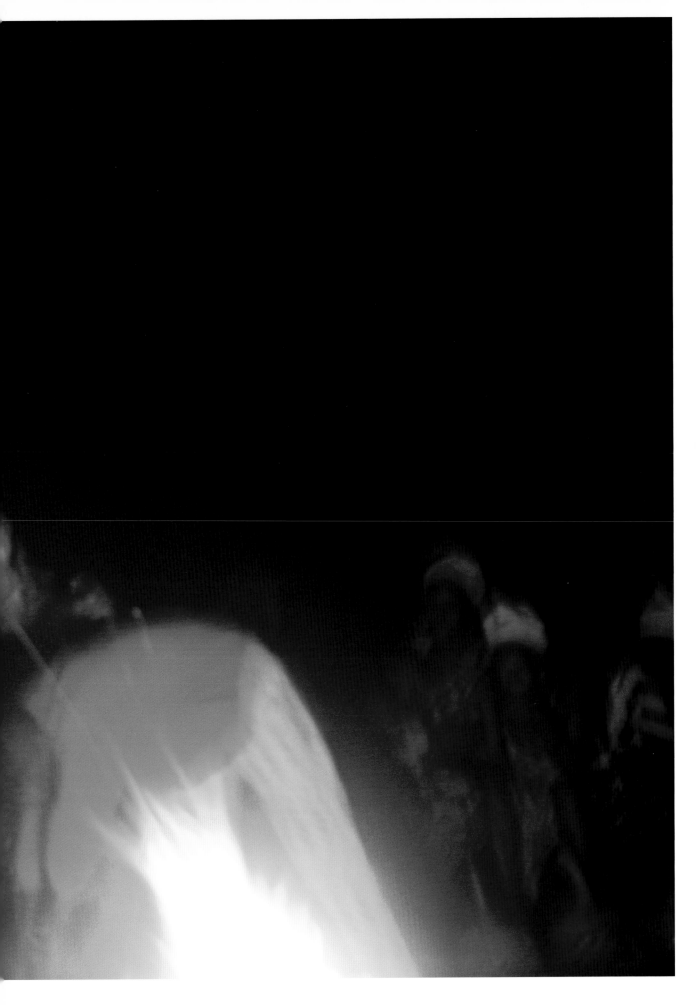

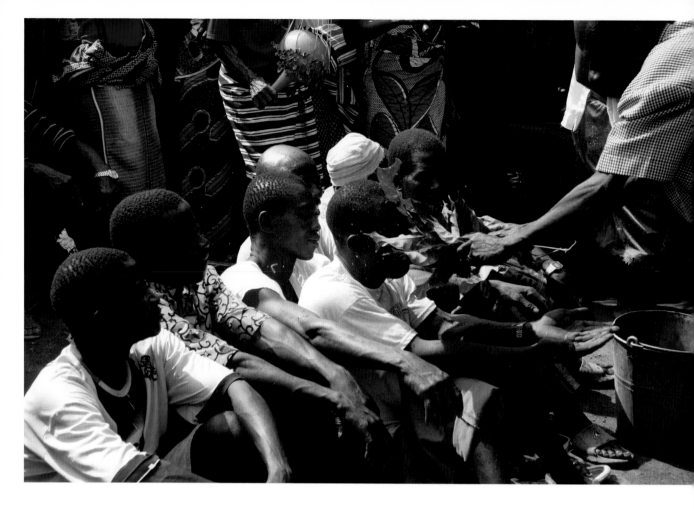

and women, chiefs, humanitarian workers, amputees and other victims of the war.

We'd found that the culture of forgiveness that I'd learned about from Tamba Ngaujah was indeed woven into Sierra Leonean life, but at the same time it seemed somehow that it was a fabric that had been worn very, very thin and was in danger of tearing wide open. Over the past month, I'd met many people who were willing to allow perpetrators to return to their communities, but those same people remained deeply troubled by the fact that the perpetrators had never apologized for what they had done.

The problem, in many ways, was that the government – at the urging of the international community – had given a blanket amnesty to all but a handful of offenders, without requiring any apologies or truth-telling in return. In addition, the government

had told Sierra Leoneans, "Di war don don" (Krio for "The war is over") and that it was time to put the past behind them and move towards peace. But with no truth and no remorse, the willingness to forgive was being strained to its limits.

This was why John's vision of bringing perpetrators and victims together in a space safeguarded by tradition and culture seemed so brilliant to Libby and me– and that's how Libby and John came to work together, and how Fambul Tok began. As the program burst into life in a few short months. my role, it was clear, was to document the story. We had no idea what journey lay ahead – but we came ready to learn, privileged witnesses to the unfolding process.

John didn't really know what to expect either; it's fair to say that the initial consultation in January 2008 with civil society members in Kailahun Dis-

(TOP) SAHR AND NYUMAH, CENTER, TAKE PART IN A CLEANSING CEREMONY HELD FOR VICTIMS AND PERPETRATORS THE DAY AFTER TESTIFYING AT THE GBEKEDU BONFIRE.

(OPPOSITE) SAHR AND NYUMAH.

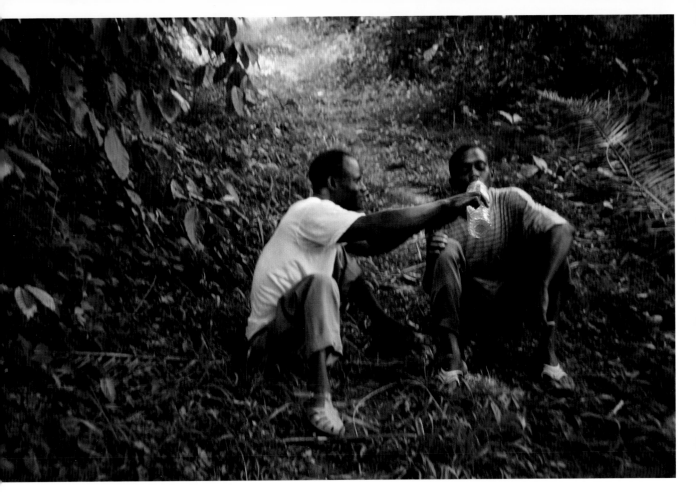

trict, where the war began, took us all by surprise. One after another, elders, women, youths, chiefs stood up to answer John's question: Do you want to reconcile? Their answer over and over again, was an unhesitating yes, a yearning to finally be able to talk about what had gone so horribly wrong, to have the conversations that would allow the truth to be told, remorse to be shown – and forgiveness to be given.

Even though the agreement among those who attended that day was simply to begin the planning process, to begin reaching out to victims and offenders, and to begin introducing Fambul Tok as a program to villages across the district, stories still spilled over into the group conversation from individuals who clearly couldn't wait for the bonfire conversations to begin.

One woman stood up and spoke quietly of the gang rape she had endured during the war, something

she had never been able to speak of; another man stood up and confessed that he had been a perpetrator during the war and that he had been longing for some way to apologize to the community for what he had done.

John was surprised at the readiness with which people were came forward, but perhaps what was most surprising during those few days was something we came to see time and again in the months that followed: the physical and emotional transformations that took place for those who finally spoke out loud to their community about what they had suffered – or what they had done – during the war.

The day after the Kailahun consultation, we were driving along a bumpy dirt road in the district when a man hailed the car and ran to the driver's window to speak to John. At first we didn't recognize him as the offender who had spoken up at the consulta-

tion; his face was literally changed, lit with the kind of light that only comes from some inner transformation. It wasn't until he spoke to John that we realized who he was; he'd flagged John down to tell him that he was overjoyed that he had been able to speak about what he had done during the war – and couldn't wait to apologize to his community at a Fambul Tok bonfire. We were all amazed at the change in the man's appearance; it was as if some huge burden had been lifted from his shoulders.

That's what we found, time and again, as we took our seat at the bonfires to listen as perpetrators and victims came forward to speak. It wasn't always "perfect" – sometimes an offender failed to show, or remained hidden in the shadows after his victim had testified, still unwilling or afraid to step forward to apologize for what he had done, and to ask for forgiveness.

Sometimes, even when a perpetrator did come forward, acknowledge his crimes, and ask for mercy, the victim would make the gesture of forgiveness (a hand touched to the back of the offender, who was bent low to the ground, at the victim's feet, in apology), but would do so almost unwillingly. No one was surprised at those times. Even though Sierra Leone's cultural mandate holds that once an offender acknowledges his crime and publicly apologizes, he must automatically be forgiven, it wasn't always easy. The elders in the community understood that reconciliation takes time, and they had committed themselves to working patiently after the bonfires, helping victims and offenders learn how to live together again in the hopes of building stronger communities.

But over and over, we witnessed people who were hungry to speak – to confess, to apologize, to forgive. And we saw them change, physically and emotionally, as the burden of the past was brought into the present – and released.

That was the case with Sahr and Nyumah, two former best friends who had not spoken since the war – when rebels captured the two boys and forced Nyumah to beat his friend so severely he crippled him and then forced him to kill Sahr's father as well. We filmed the bonfire where they came for-

ward to speak, not catching all the details of what had happened between them. The next day the two sat down to speak with us on a rough wooden bench not far from the ashes of the previous night's bonfire.

Sahr was composed as he recounted again the story he had told the night before; Nyumah's face was drawn and haunted as he listened, even though he had already been forgiven, had already bent low before his friend and received the touch of forgiveness, had already danced arm in arm with him around the bonfire. When Nyumah spoke during our interview, he said the guilt for what he had done still remained – but that with his friend's forgiveness, he hoped he would get better in time.

When the interview ended, I leaned forward towards the two of them; like my crew, I was fighting back tears, moved by their story. "I'm so sorry this has happened to you," I said. "We all hope that you will be able to sit together, like you are now, as friends once again, for many years to come."

The two boys shifted on the bench, Nyumah awkwardly starting to offer his hand to the friend he had wounded so badly. But Sahr turned the offered handshake aside and instead put his arms around his friend, Nyumah returning the embrace, the two of them finally starting to laugh. A few minutes later, as they walked away, Sahr stumbled – clearly in pain as a result of the beating by his friend that had left his hips disfigured and made it nearly impossible for him to walk. In one quick gesture, Nyumah reached out and took his best friend's hand, helping him stay upright on the jungle path. They slowly walked away, hand in hand.

We saw Sahr and Nyumah two more times after that. We hiked miles into the jungle to reach their villages (they live a mile apart), to ask how they were doing, to see if the friendship had truly been restored. It had, without doubt. They couldn't stop smiling when they were together, joking with each other, sharing whatever they had – a cigarette, an orange, some water. Nyumah had already begun to help Sahr by working on his farm, and had plans to help build a new house for him. The two had

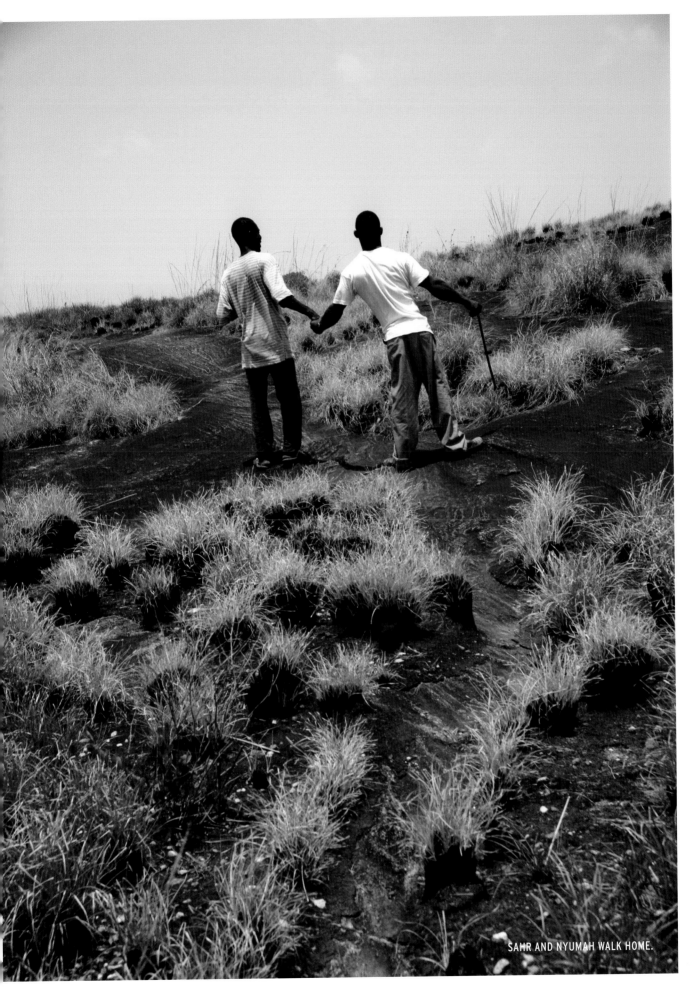
SAHR AND NYUMAH WALK HOME.

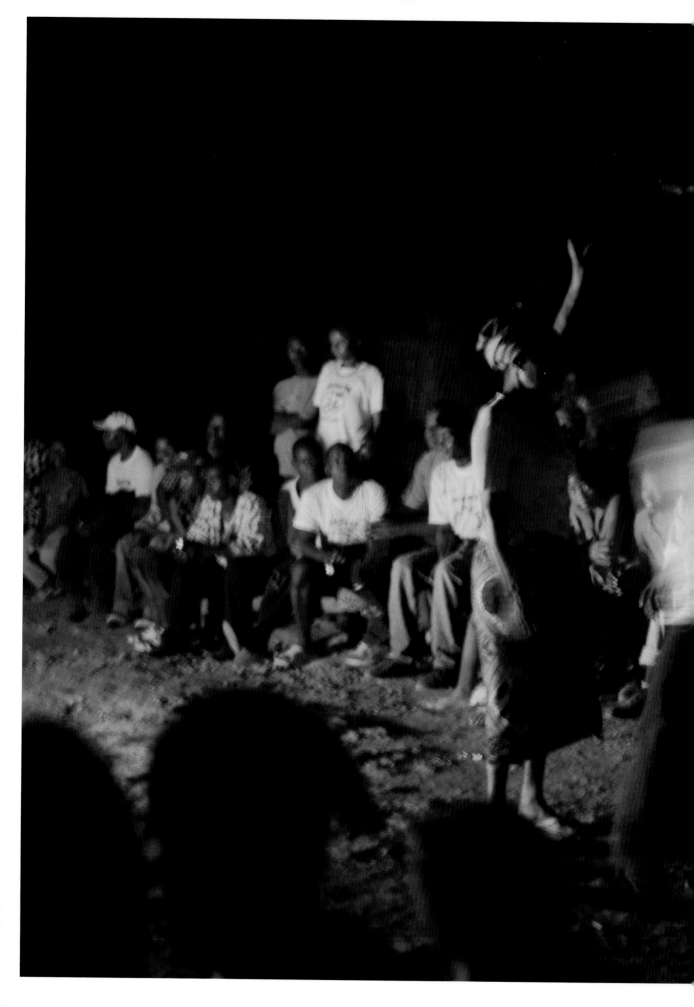

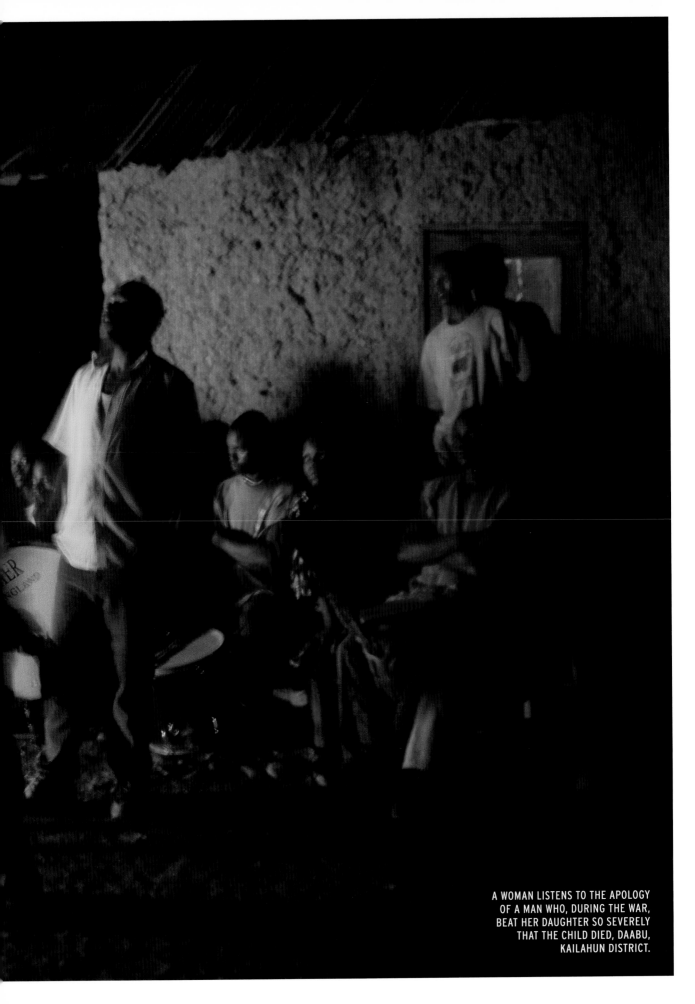

A WOMAN LISTENS TO THE APOLOGY
OF A MAN WHO, DURING THE WAR,
BEAT HER DAUGHTER SO SEVERELY
THAT THE CHILD DIED, DAABU,
KAILAHUN DISTRICT.

changed physically as well – their faces had filled out; Nyumah's, in particular, no longer wore the grim, strained look he had when we interviewed him in the clearing. Each time I was with them, I couldn't help feeling their unrestrained joy at being friends again; it was as if the greatest pain that either of them had suffered was the loss of contact, the loss of a loved one who was still living but who for all intents and purposes was dead – separated by a gulf of guilt and silence. Fambul Tok brought them back to life.

Over time, I came to see that Fambul Tok did more than bring personal relationships back to life; it helped whole communities experience a rebirth, as conversations that had been frozen, silenced, during the war and after it, were finally unleashed in the safety of the space created by a Fambul Tok bonfire. And as these words of sorrow, of pain, of remorse, of forgiveness were spoken – and heard in the presence of neighbors – new relationships

began to be forged, which in turn helped strengthen the entire community.

I saw this most clearly in the village of Daabu, Kailahun District, one of the last places we filmed. Their bonfire was held almost nine months after the first bonfire in the district, and perpetrators jumped up all night long to apologize for what they had done during the war and ask for forgiveness. The scope of the incidents discussed covered a full spectrum related to the life of the village – from harm done to individuals, to theft, to a long-held grudge against a chief for wrongdoing, to destruction of the village's small, but prized, "court barrie," which had been the site for discussing all matters related to the village. It was by far the richest bonfire we had attended, in terms of stories told and engagement by the community.

The next morning when we returned to interview those who had participated in the bonfire, I was still

(TOP) AFTER ACCEPTING HIS APOLOGY FOR KILLING HER DAUGHTER, A WOMAN DANCES WITH THE MAN SHE HAS FORGIVEN, DAABU, KAILAHUN DISTRICT.

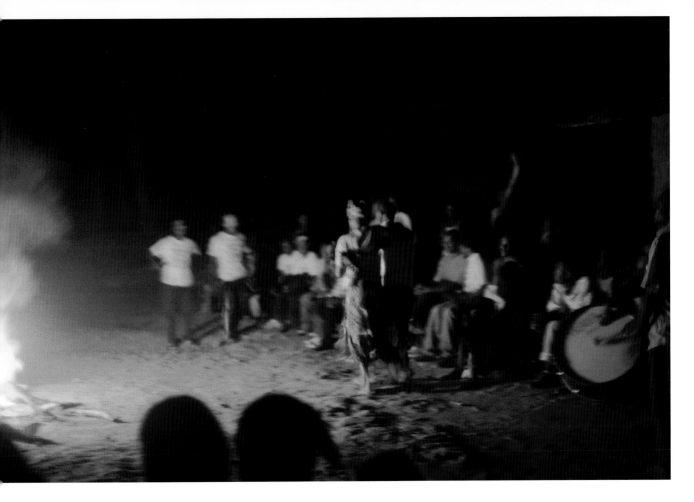

thinking of the revival that had been happening in front of us the night before. But what I saw when I got out of the car was a scene that I had seen many, many times before: utter poverty. Tiny mud houses with rusted, patched-together zinc roofs, scantily clad children, signs of malnutrition. Hard for me to reconcile with the wealth I'd felt the night before, the riches of a culture that sought justice through forgiveness and reconciliation, the invaluable wisdom of people who understood that revenge would only destroy the things they held dear.

It was my "a-ha" moment. After nearly a year and a half of working on the film, I finally realized what John Caulker saw every time he entered what to my Western eyes looked like a devastated community. Where I saw hopeless poverty, John saw the wealth of his culture, and the bountiful human resource of the people who believed that embracing their culture – and one another – was the only way forward, the only way to lasting development. Finally,

I was beginning to see through John's eyes – and to understand why humanitarian workers who came thinking that the West had all the answers to Sierra Leone's problems so often failed in their efforts to help rebuild.

Like almost every other village that had gone through the Fambul Tok process, Daabu created a community farm, where victims and perpetrators could work side by side – strengthening the bonds of reconciliation that had begun with apologies and forgiveness. That harvest season, there were bumper crops all across Kailahun District – the poorest district in one of the poorest countries in the world. The district's Fambul Tok executive committee, made up of locals, had even drawn up a budget, with plans to use money raised from the community farms to help support further reconciliation and development. But that wasn't all: the budget included a line item that, within a few years, would share revenues from the community farm harvests with the Fambul

Tok national program, so that the people of Kailahun could help pay for ceremonies in other parts of their country. Talk about resources. Talk about transformation.

I also saw another kind of transformation during the 18 months we shot the film – the impact of Fambul Tok on a perpetrator who had stubbornly refused to admit any wrongdoing whatsoever. We met Captain Mohamed Savage – one of the most infamous alleged perpetrators of the war – in the last 72 hours of our last trip for the film. I'd known of him for years, and the stories of what he had done – the brutality of the killings and maimings he was accused of ordering during the war. He was notorious among human rights activists in the international community, as well; they had lobbied hard, but unsuccessfully, for him to be included among the small group of men who were indicted by the Special Court as bearing the most responsibility for the war.

I wanted to meet Savage to ask him what he knew about the story of Tamba Joe, which plays a key part in the Fambul Tok documentary. Joe was accused of killing and beheading 17 of his own relatives in the village of Foendor – and bringing the heads to Savage. I had been trying to interview as many people as possible about what had happened that day, and I'd wanted to hear Savage's version of the events, even though the idea of meeting such a notorious offender was hard for me to imagine.

John finally tracked him down in a neighborhood in Freetown, just a few days before the film crew and I were scheduled to return to the US and begin editing. I was surprised to discover that day, on a street corner in an unremarkable neighborhood, how small Savage was, and how young, probably still in his 30s. In my mind's eye, I'd imagined such a killer as a hulk of a man, an older man, one who had grown hardened over many years. I shook his hand and struggled within myself for showing any kind of decency to a man who'd done the things he'd been accused of doing.

From the moment we told him what we wanted to talk about, he denied that he had ever been near the village where the killings by Tamba Joe had taken place; he denied knowing Joe; he denied ever having committed any atrocities during the war; he insisted that people were confusing him with another Captain Savage.

I assumed any further conversations would be fruitless. Savage said that if I had a few weeks, perhaps we could talk another time, because he wanted to talk about his own story, but he wasn't prepared to talk then because I was a stranger to him. I shrugged; I understood his reluctance. But I was heading home, and as far as I was concerned, I'd finished shooting the film – which I was sure would end with the story of Tamba Joe's failure to come home to the bonfire where an entire village was willing to forgive him. It wasn't a happy ending, but I felt it was an ending that showed the hard work that goes into Fambul Tok, and that the work of reconciliation doesn't happen overnight.

But, for some reason, Savage persisted. He asked us to come back the next day, with John, to meet at one of his local hang-outs. We agreed to be there, even though I expected little to come from it. And nothing did seem different when we sat down with Savage that afternoon in a little restaurant that remained closed to other business while we were there.

Savage denied everything all over again. John listened quietly at first. And I lost my patience. I wound up speaking out in a way I probably never would have done, were it not for the fact that I was sure we'd finished shooting the film and also that I'd found myself quietly upset by Tamba Joe's failure to go back to his village to reconcile, disturbed that he had wasted an opportunity to encounter such a generous moment of goodness. It was a frustration that carried over into my conversation with Savage.

"Okay," I said, as he categorically refused having set foot in Kono District, where his crimes were reportedly so heinous that locals named a pond "Savage Pit" because of all the people whom the captain had allegedly ordered killed and disposed of in the pond. "Okay," I said to Savage that afternoon, "let's say that you aren't the Savage that everyone talks about in Kono District. It's some other guy. All you

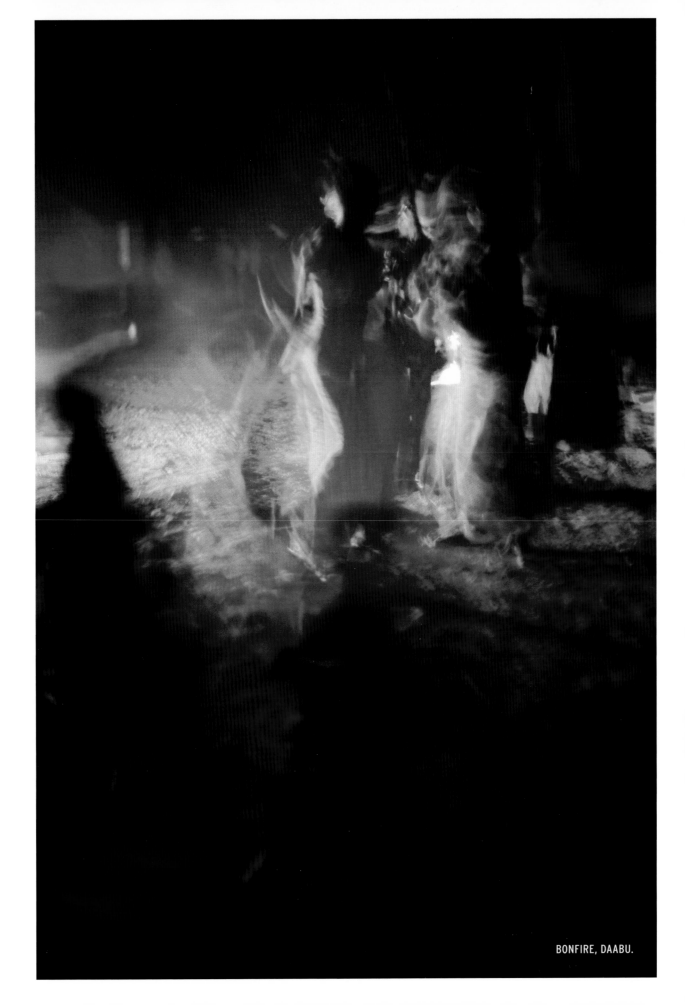

BONFIRE, DAABU.

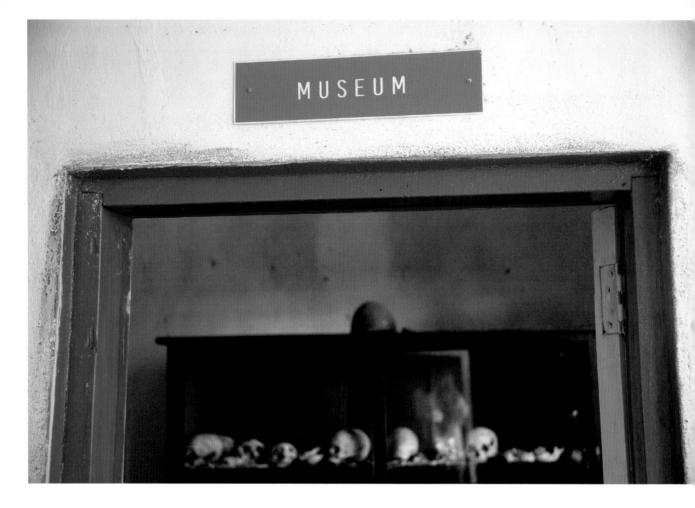

MUSEUM

have to do," I said, "is go back to Kono and show your face and people will realize they've confused you with someone else."

"But if you are the Savage they remember," John chimed in, "then perhaps it's time for you to ask for forgiveness and to begin reconciling with your people."

It went on like that for an hour or so; the only reason that we have any footage from that meeting is that my film crew was smart enough to set up camera and sound (with Savage's permission) to capture the exchange. I didn't think of it as an interview; it seemed to be more of a futile parrying of words with a stone-cold liar. But for some reason, neither John nor I gave up. We spoke to Savage about what we had seen in the communities where Fambul Tok had been, of the ways villagers had grappled with painful stories and yet still been willing to forgive, to restore the wholeness of the community. We

talked about living in light, instead of darkness; we spoke about the new life that can emerge once the truth has been spoken.

Savage was having none of it. In one last attempt to crack his facade, I asked if he would like to see a short video message I had on my laptop. It was a message from Naomi Joe, Tamba Joe's sister, to play for Joe in case we found him, a message full of love and a plea to come home, a message that told him of the willingness of villagers to accept him back into the community.

I sat just a few feet away from Savage as he watched Naomi Joe on my computer screen, and I saw nearly imperceptible physical changes in his demeanor, including quick, short, shallow breaths as the message played. I thought we'd begun to get through to him, but when the short video was over, Savage took off the headphones and said he didn't know anyone named Tamba Joe. We left him then, head-

(TOP) MUSEUM IN TOMBODU, KONO DISTRICT, CONTAINS THE REMAINS OF VICTIMS OF A MASSACRE, MOST OF WHICH WERE EXCAVATED FROM SAVAGE PIT.

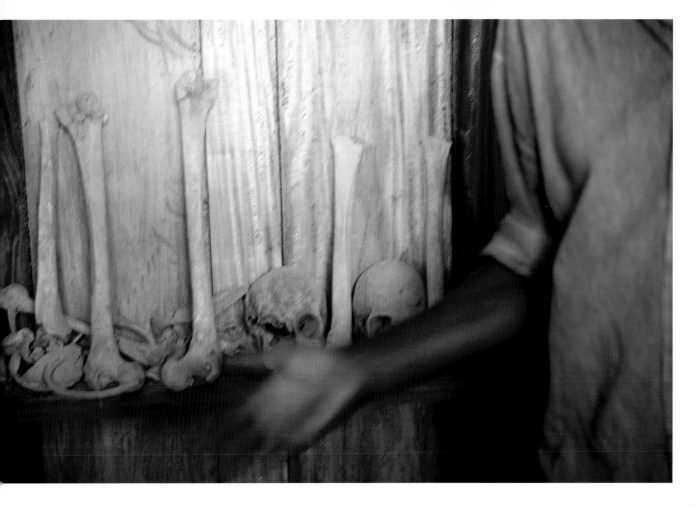

ing back to our hotel to pack for our flight the next afternoon.

In the hours that followed our meeting, something happened. Savage called John three times that evening, insisting that he needed to talk; the two set up a meeting for the next morning. John called before it happened, telling me to be prepared – he thought Savage might be ready to talk more openly.

And, as things turned out, Savage did want to talk. When we saw him that morning, after his meeting with John, he was a visibly changed man. His arrogant, defensive posturing had been replaced with a brokenness, almost an exhaustion, as he stopped denying that he was the Savage that everyone was talking about. His eyes filled with tears as we spoke (cameras rolling from the beginning, this time), catching all of us off-guard. I found myself feeling compassion for a man I knew had behaved like a monster. I didn't know what to do with that feeling,

how to respond to such a dramatic transformation, whether to even believe it. So I listened.

It was Naomi Joe's message that had cut Savage to the quick, crumbling his defenses. It was as if it was the message was meant for him personally, he told us, as if it had come from his own sister. Although he stopped short of confessing to specific crimes, he alluded to things he had done; he also insisted that he had not done everything that he had been blamed for – but he acknowledged he had done some of it. And he knew he needed to come clean. Savage asked John for help that morning, to find out if people in Kono District really were ready to reconcile with him. John promised that he would.

We stayed to talk briefly with John after Savage left that day. None of us had ever witnessed such a dramatic transformation in an individual, in a matter of hours. We were in awe of the events that Fambul Tok had set in motion. John, in particular, under-

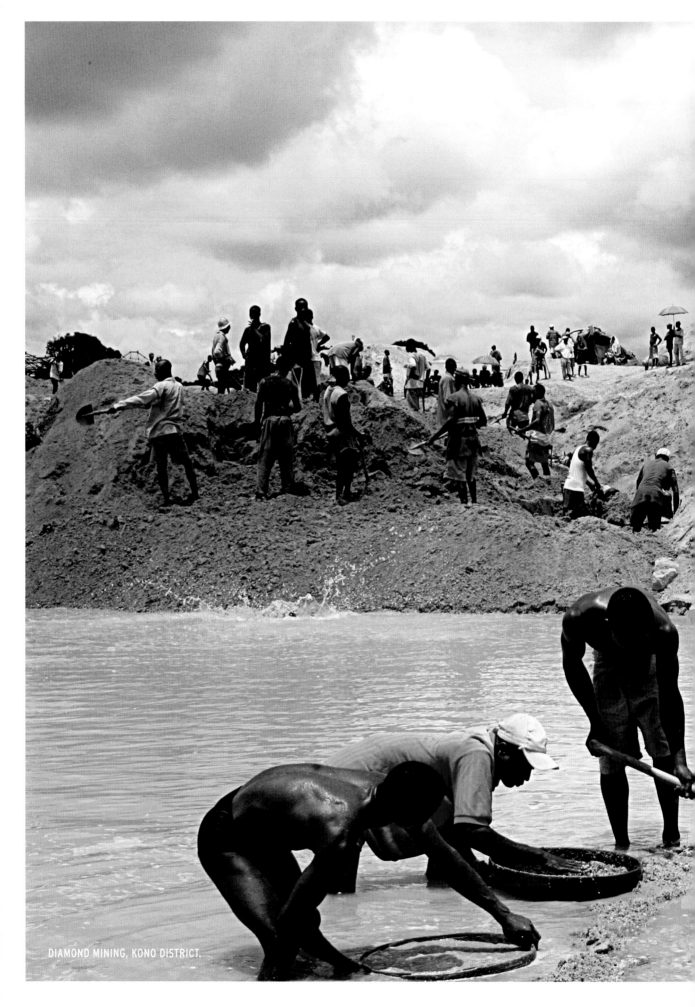

DIAMOND MINING, KONO DISTRICT.

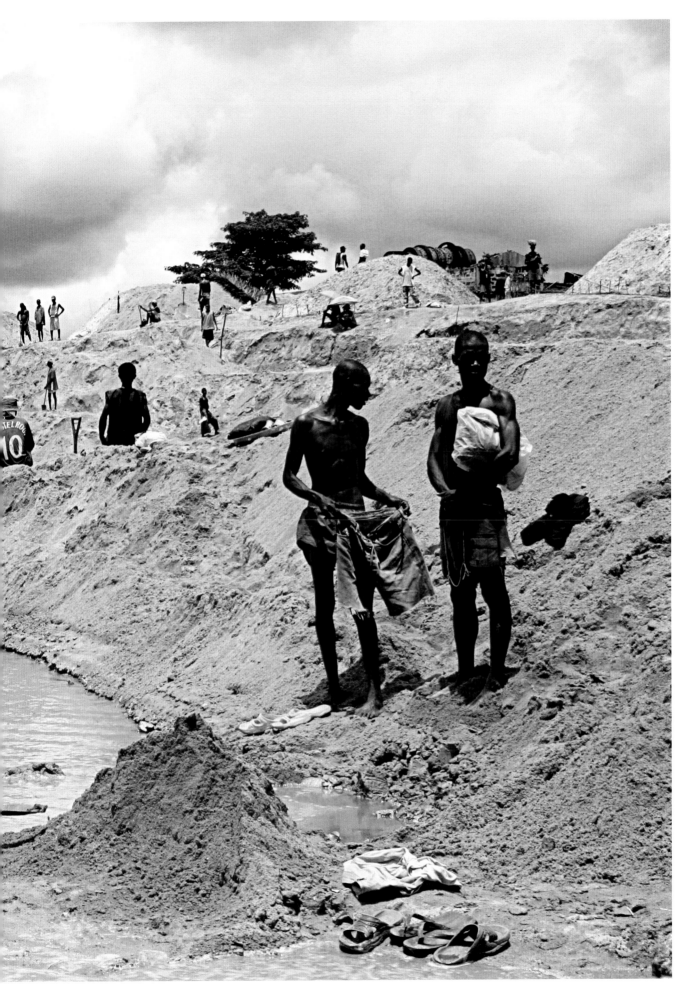

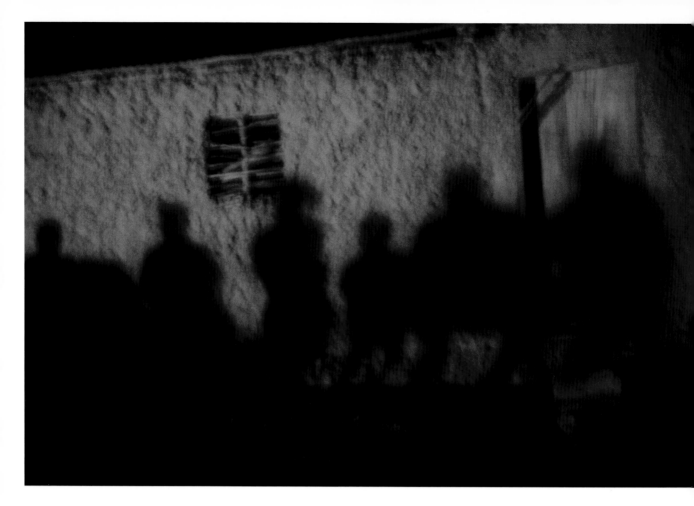

stood the impact of a high-ranking offender such as Savage coming forward to confess and ask for forgiveness. He was sure the floodgates would open – that other high-level commanders who had been afraid to come forward would also begin returning to the villages they once terrorized, to confess, to apologize, to be forgiven. The transformation that John had longed for, his country's return to its culture, the reconciliation of his people, was happening before our eyes.

A month or so after our meeting with Savage, Caulker found out that the Special Court could still issue indictments, even though it was beginning to wind down the trials that had begun in 2004. Although Savage remained willing, even eager, to testify at a Fambul Tok bonfire, John and his staff thought the risks were too great – both to Savage personally and to the program itself. Savage's return to Kono District would have to be postponed.

As I write this, Savage still has not been able to return home, to ask for forgiveness. It will happen, though. John promised that he would be there, to help Savage and his community on that long road to reconciliation. It's a matter of timing, of making sure that the sacred spaces Fambul Tok creates for conversation are safe enough for this particular conversation to happen. But the day will come, of that I am sure.

October 2010

POSTSCRIPT, NOVEMBER 12, 2010

Tombodu, Kono District: Nearly eighteen months after we first interviewed Captain Mohamed Savage, we have come to Sierra Leone once again – this time, to witness his apology to the people of Tombodu. Just a few short weeks earlier, we'd heard that Savage had decided he could wait no longer (even though the Special Court has not yet completely closed down). He'd informed John that he was going home, and asked for Fambul Tok's help. In a few short weeks, the groundwork had been prepared – most importantly, gaining the approval of the

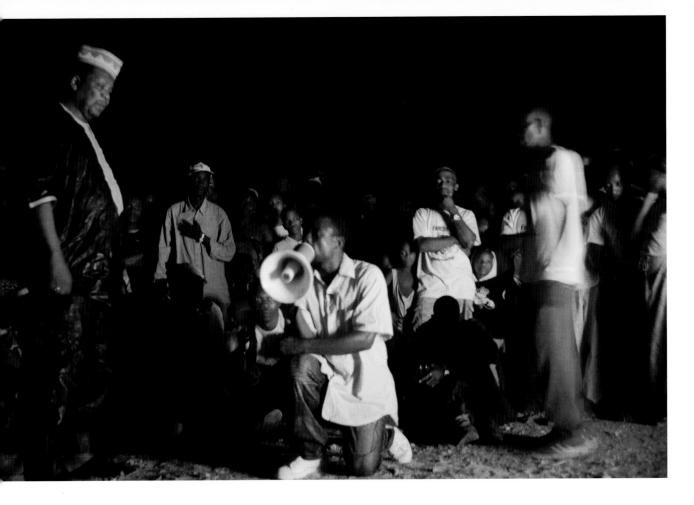

Paramount Chief and the town and section chiefs who debated long and hard whether they wanted to allow Savage to come before their people. Their answer, in the end, was, "Yes, let him come."

And so he did, to face hundreds of people who could hardly believe that the legendary Captain Savage would be among them that night. But there he was, using a megaphone so he could be heard to the farthest reaches of the crowd, going down on to bended knee to ask for forgiveness, accepting responsibility for everything that had been done under his command, even for those things that had been done without his knowledge or his orders. He did not address specific cases, or specific individuals, that night, though he promised that in the days and weeks ahead he would meet with any- one who had charges to lay against him, and to apologize. His intention, he made clear, was to stay among the Kono people, to continue a recon- ciliation process that was only beginning that night – one that would require a long, long journey in the months and years to come.

The people of Tombodu accepted Savage and his apologies that night, hailing the return of a prodigal son. Even the Paramount Chief, who originally had said he never wanted to see Savage again, said Sav- age had done well, had done the right thing. "I've changed my mind about him," said the Chief. "I've begun to see him as a human being."

There is no way of telling, at this writing, what impact Savage's apology will have on the country as a whole – though John Caulker is sure that a new chapter in the story of Fambul Tok has begun, a new chapter in the story of post-conflict Sierra Leone. I come away, as always, humbled by the people and culture of this country – convinced that there is still so much to learn from them.

(LEFT) SHADOWS CAST BY THE FIRE, KONGONANIE, KAILAHUN DISTRICT.
(ABOVE) MOHAMED SAVAGE APOLOGISES AT A BONFIRE, USING A
MEGAPHONE TO BE HEARD BY THE CROWD.

THE SUN SHINES THROUGH PALM TREES.

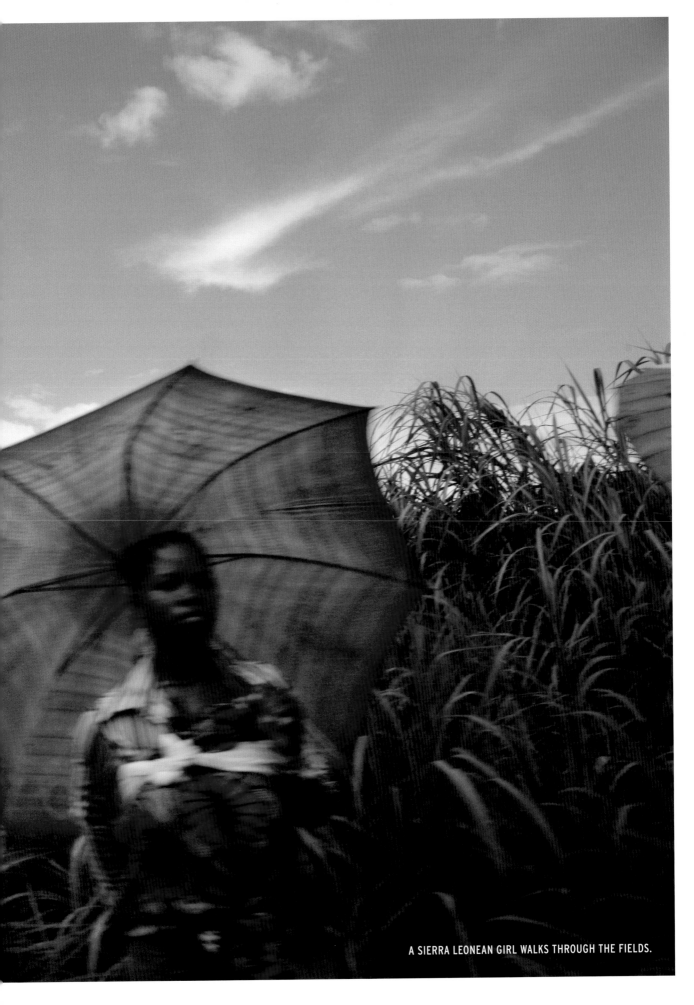

A SIERRA LEONEAN GIRL WALKS THROUGH THE FIELDS.

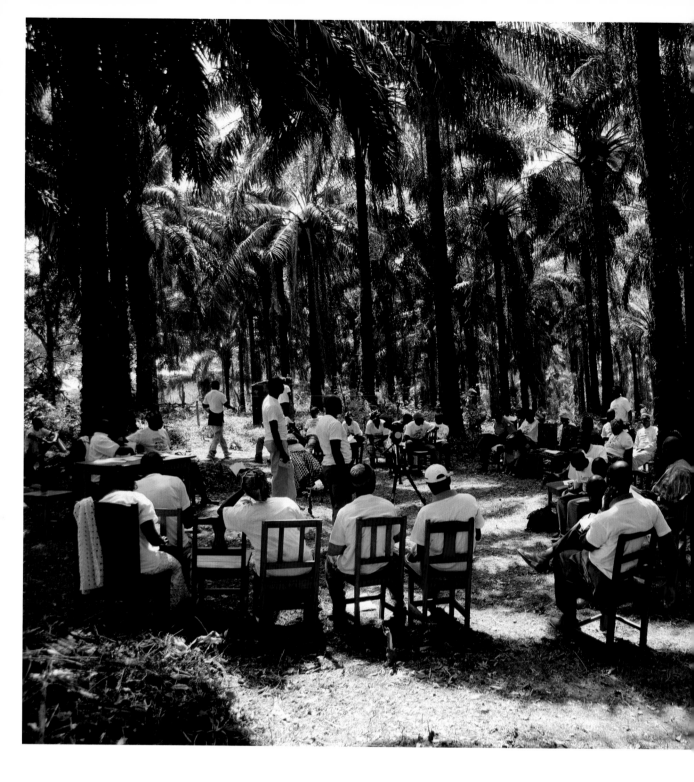

FAMBUL TOK COMMUNITY CONSULTATION, KAILAHUN DISTRICT.

HOW IT WORKS: AN IN-DEPTH LOOK AT THE FAMBUL TOK PROCESS

Co-founder and President of Fambul Tok International, Libby Hoffman has worked in international peacebuilding for over twenty years as a professor, trainer, program designer, and funder. She founded Catalyst for Peace in 2003.

With the Truth and Reconciliation Commission (TRC) over, and the Special Court coming to a close, Fambul Tok in Sierra Leone is meeting the demands of this new phase in the country's post-conflict landscape. Although the TRC provided a detailed account of the war and opportunities for a limited number of people to tell their stories, Sierra Leoneans have expressed a need for opportunities for victims, perpetrators, and communities to address the wounds and issues from the war, which continue to divide families and communities and could, if unaddressed, lead to renewed violence. Fambul Tok addresses the roots of conflict at the local level, helping war-affected individuals reflect on the past in ways that enable them to be a part of averting renewed aggression. By grounding reconciliation in traditional practices, it also helps create healthy communities capable of building new foundations of peace.

In the first two-and-a-half years of the program there have been more than 75 reconciliation ceremonies in communities across the country. The first ceremony took place in 2008 in the place the war began, the eastern province of Kailahun, and Fambul Tok has spread out steadily from there, first in Moyamba District in the south, then Kono District in the East, and then into Koinadugu District in the North at the beginning of 2010. By rolling out in

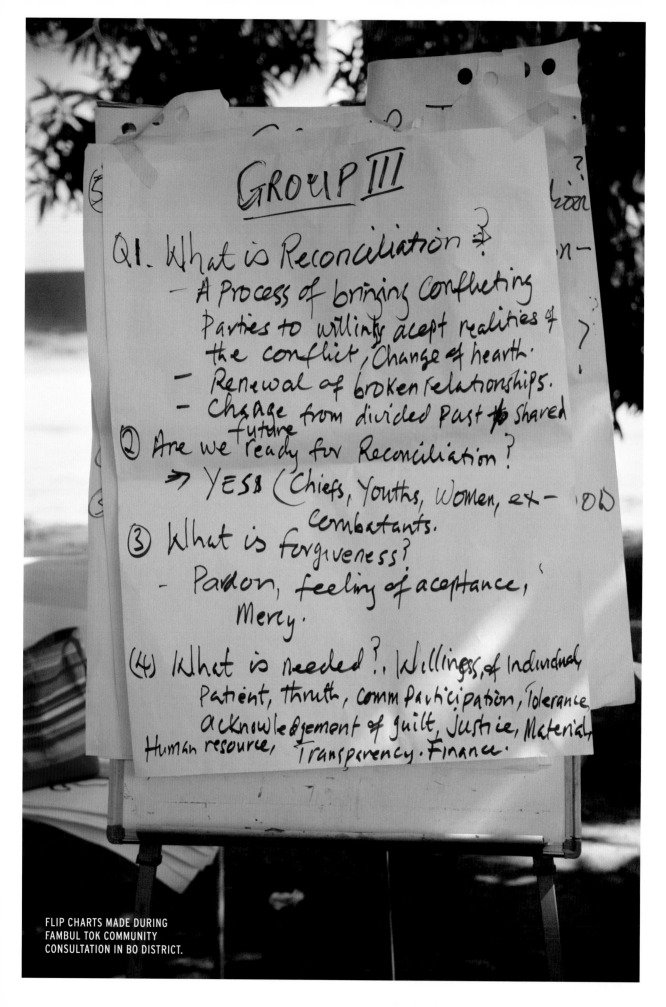

GROUP III

Q1. What is Reconciliation?
- A process of bringing conflicting parties to willingly accept realities of the conflict, Change of hearth.
- Renewal of broken relationships.
- Change from divided past to shared future

② Are we ready for Reconciliation?
⟹ YESS (Chiefs, Youths, Women, ex-combatants.

③ What is forgiveness?
- Pardon, feeling of aceptance, Mercy.

④ What is needed?. Willingss of individual, patient, thruth, comm participation, Tolerance, acknowledgement of guilt, Justice, Material, Human resource, Transperency. Finance.

FLIP CHARTS MADE DURING
FAMBUL TOK COMMUNITY
CONSULTATION IN BO DISTRICT.

three new districts a year, the program hopes to be covering the entire country by 2013.

OVERVIEW

Originally conceived as a chiefdom-level program that would involve 161 ceremonies around the country, Fambul Tok has evolved to meet the needs of fellow Sierra Leoneans, who have asked for ceremonies to be held at the much smaller level of village groupings—known as "sections"— that will involve thousands of ceremonies to be held over the next several years.

Following the ceremonies, Fambul Tok works with the communities to organize activities to support and sustain the reconciliation process. These have included: radio-listening clubs, football matches, and even village-initiated community farms; projects through which newly reconciled individuals are able to come together for the good of the community.

Fambul Tok is a distinctly Sierra Leonean initiative. It is not rooted in Western concepts of blame and retribution, but rather in African communal sensibilities that emphasize the need for communities to be whole, with each member playing a role, if peace and development are to be achieved for the nation at large. It is inspired by the conviction that each person has the power, goodness and capacity to contribute to society in helpful and healthy ways. However, when people experience violence and hurt, those innate capacities can become suppressed, often causing individuals to act in ways contrary to their nature. By reviving traditional practices that have proved effective in the past, and by empowering local leaders to provide ongoing guidance and moral support in the process of forgiveness and reconciliation, Fambul Tok helps restore people and communities to wholeness.

––––––––––––

"For now, I can't say the place is peaceful. [The Special Court] is targeting those who bear greatest responsibility, but what about somebody who has done wrong to somebody in a village, and both of them are living in that community? Dealing with Charles Taylor—will that solve the problem? No. That will not solve the problem. It is good for people living in the community to reconcile first within themselves. You as a perpetrator ask the victim for forgiveness so that will permit a reconciliation process."
—Satie Banyah, Youth Leader In Kailahun District

"You are left with a lot of people with scars on their minds. The healing process is a slow one, but the healing of the mind is what's important. The only way the mind can heal is bringing all the parties together, the perpetrators and the victims.

My God, if we do not reconcile within the next two, three, four years—I am afraid we are sitting on a time bomb. It's an emotional time bomb, a volcano. It's steaming down there. It just needs one thing to spark it off. I wouldn't like to see my country go back to war, for nothing. I want my country to be free, for us to live together as one. I think Fambul Tok can help to a large extent."
—Reginald Strasser King, Journalist, Freetown

COMMUNITY-BUILDING METHODOLOGY

Though the bonfires and cleansing ceremonies are the focal points of Fambul Tok's engagement with communities in Sierra Leone, the Fambul Tok approach—its community-building methodology—is as crucial to its success and sustainability as the bonfires themselves. Fambul Tok works to reweave the social fabric of communities by mobilizing community members to design and run their own healing processes: there's nobody coming in from the outside, saying 'Let me show you how to do these things.' Fambul Tok gives people the opportunity to say what they want in their experience, to look at the resources they already have, to decide what they want to do. This approach takes much more time than typical host-an-event-and-leave approaches. In the end, the impact is much deeper, more widespread, and the process becomes sustainable for the communities themselves.

Reconciliation by rebuilding community makes possible more than peace; it lays a foundation for development, as envisioned and enacted by the communities themselves. This is especially visible in the more than 60 "peace farms" (as of mid-2010) Fambul Tok communities have planted across the country. To strengthen their renewed relationships (and also to provide an avenue for perpetrators of the violence to engage in a measure of reparations for the people and places they harmed), villagers have decided to share the work and rewards of a community farm. They clear brush, plant seeds, pull weeds, and even scare birds away together. They harvest together, and together they decide how to invest the earnings from their peace farm. In Kenewa village in Kailahun, they bought a roof for their community barrie (a public meeting space). In Bandasuma village in Kono, they put some of their income toward building a covered market to protect the women who sell the town's produce from sun and rain. In Madina village, and also in Kailahun District, they bought cement and built a barrie.

Each of these villages, and hundreds of others, are doing more than earning extra income. With every decision they make as a community, every project they implement, they are imagining a future that is shared once again. Empowered by Fambul Tok to take control of their community's needs, villages are setting new agendas. From buying a rice-hulling machine to sending more children to school, they are articulating their needs and desires—in their own time and on their terms—and they are making their vision a reality.

WOMEN IN FAMBUL TOK

Given our values of total community participation and ownership, we have incorporated women's

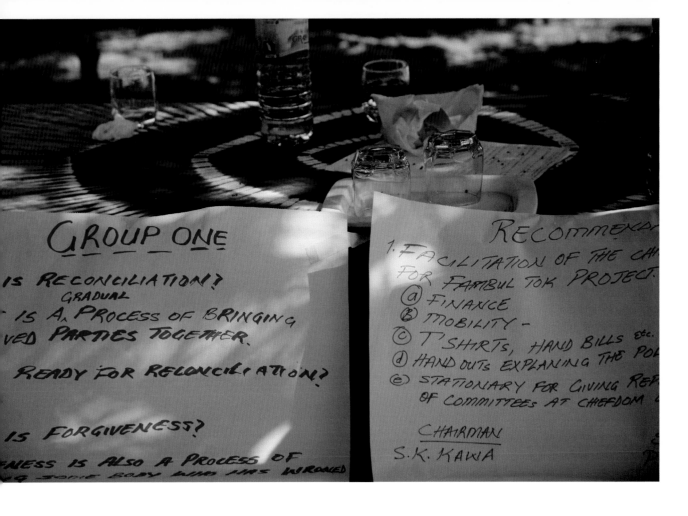

participation into every aspect of design and implementation, and into every community structure we help put in place. The transformation of social space that this has enabled is significant.

Thousands of women were raped or abused during the war, and they have largely born their burden in silence. Rape is a taboo subject in Sierra Leone, and many rape survivors are shunned. Yet at virtually all the Fambul Tok bonfires, women come forward to tell their war stories, including those of sexual abuse, and to accuse their perpetrator in public. Specific community-based follow-up activities provide an ongoing supportive space for these women after they testify. (See Peace Mothers section for more detail.)

To date, thirty percent of testifiers at village bonfires have been women. Testifying takes an extraordinary amount of bravery on the women's part. Yet,

in village after village, we have seen bonfires transform social space. Hierarchies disappear and every person, from the poorest farmer to the paramount chief, is equal to the man or woman next to them. That makes it possible for women to share all kinds of unexpected stories, even stories that accuse their leaders. In any other context, a woman who calls out a chief in public, much less accuses him of a crime, can be thrown in jail. But Fambul Tok's approach to reconciliation transcends even this social rule, opening space for truly honest conversations.

"The approach Fambul Tok brought into these communities – they didn't say, 'It's my program, an NGO program. We'll do this for you, we'll do that for you.' They come to people, they say 'We're not going to tell you what to do. We're the same as you. We're all Sierra Leoneans. This program is your program. Whatever way you want to organize, it's yours, your

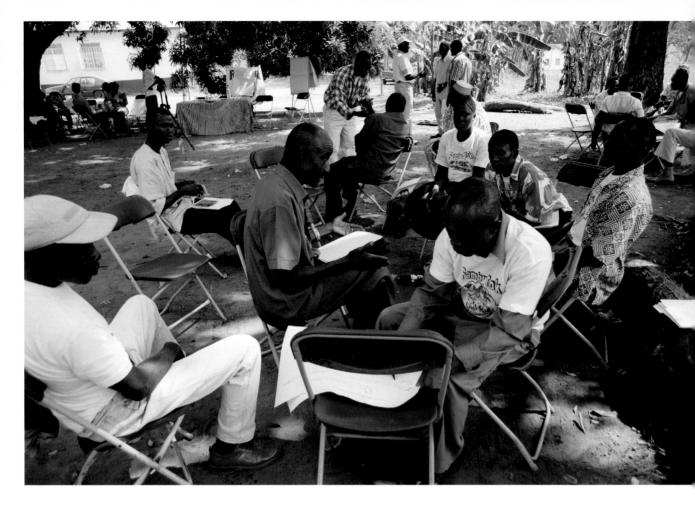

tradition.' Fambul Tok has given the people the right to own the program. For the fact that they are doing it their own way, that's why Fambul Tok is succeeding."
—James Fallah, Journalist, Kailahun District

"With the RUF [Revolutionary United Front] members who have stayed amongst us, we want peace and we want reconciliation at the grass roots. And Fambul Tok is with us down to the grass roots."
—Isata Ndoleh, Mommy Queen,
Kailahun District

"Unity is stronger than money. Fambul Tok has united us as most families were divided after the war."
—S.W. Folleh, Section Chief, Kuudu,
Kailahun District

THE PROCESS, IN DETAIL: IT ALL BEGINS WITH CONSULTATIONS

A hallmark of the Fambul Tok approach is that each new program phase begins with a consultation with the impacted community. Rather than enter communities with a predesigned program to be replicated, Fambul Tok follows a process of "emergent design," drawing on local perspectives and ongoing assessment and reflection to allow the program design to emerge directly from the affected communities, and then to adapt to the changing circumstances of real-world events and social change processes.

The program was officially launched in December 2007, with regional pre-consultations held in the cities of Kenema, Bo, and Makeni (in the eastern, southern, and northern regions of the country, respectively). With representation from Sierra Leonean civil society organizations and national stakeholders, this initial testing of the waters to assess community needs and interest in reconciliation verified the need for extensive, district-level consultations in each of the country's fourteen districts.

Next, a round of district consultations held across the nation from January to March 2008, engaged a

(LEFT, RIGHT) COMMUNITY CONSULTATIONS IN
BO AND KAILAHUN DISTRICTS.

wide spectrum of participants – traditional leaders, women's groups, youth groups, community stakeholders and local government officials, among others – to discuss the process of facilitating reconciliation in their respective communities. To ensure total participation during the consultations – a key Fambul Tok value – participants were divided into groups to discuss questions such as:

What is reconciliation?
Are we willing to reconcile?
What is forgiveness?
What are some possible/preferred methods of reconciliation?
What does your community need for reconciliation?
What is already available in the community?
How can Fambul Tok support community initiatives?

The need for genuine reconciliation was overwhelmingly voiced, and the stakeholders in every district suggested that the process focus on traditional methods.

Some consultations recommended what could be termed mass reparations, such as memorials, reburial of bodies from mass graves, and symbolic monuments as helpful first steps for reconciliation in their communities. The consultations culminated in nationwide approval for Fambul Tok and the formation of the initial district structures to help facilitate the process.

One of the most common themes from the consultations was the need to make the Fambul Tok process accessible to all. A common complaint about the Truth and Reconciliation Commission (TRC) hearings was that they were all held in the district headquarter towns, for a maximum of five days, thereby limiting participation to those who could afford to travel. Although the original Fambul Tok plan was that ceremonies would be held at the chiefdom level, in the consultations this was seen as potentially limiting people's access and ability to participate. As a result of the consultations, the decision was made to ensure universal access by holding reconciliation ceremonies at the sectional level (sections are usu-

FAMBUL TOK: HOW IT WORKS

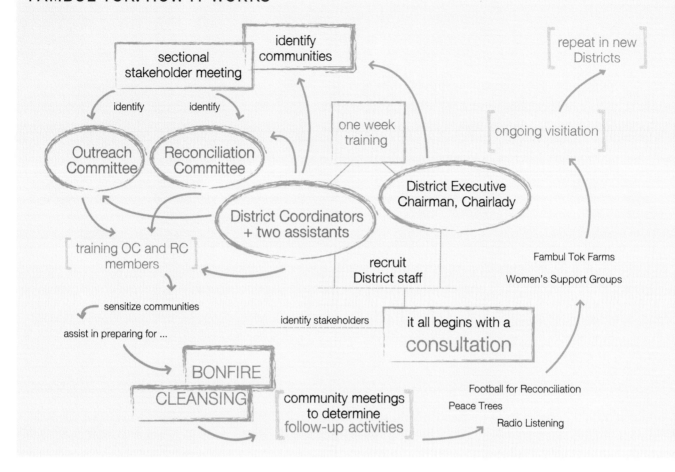

ally composed of between five and ten villages).

After a six-month trial of the program in Kailahun District, the approach crystallized and the full reconciliation cycle of Fambul Tok took shape.

"Before the war itself, our parents used to carry out some traditional practices...to facilitate reconciliation processes in our country. We believe that if we can closely look at some of the cultural practices that we used to carry out that it will help to build the situation for ourselves in our country."
—Satie Banyah, Youth Leader, Kailahun District

HOW IT WORKS, EXPLAINED

The first step of any Fambul Tok process is a consultation. Sierra Leone has 14 districts, similar to states or provinces, around which Fambul Tok organizes its work. The Fambul Tok national staff gathers stakeholders from each chiefdom in the district to discuss whether communities are ready to reconcile and, if so, how they want to go about it. When ready to go forward, the stakeholders elect a District Executive (DE), an all-volunteer group drawn from across the district that will oversee the Fambul Tok program. A District Coordinator (DC) and two assistants are recruited as staff to serve as the engine for the process, working in close partnership with the District Executive. These two groups receive extensive training in the Fambul Tok values and process, as well as in reconciliation, mediation, and trauma healing.

They begin working immediately at the grassroots "sectional" level. A section is a collection of usually five to ten villages. A series of initial sectional meetings leads to identifying the communities most

ready to engage in Fambul Tok.

Once a section is identified, the district staff and members of the executive work with them to identify Outreach Committee (OC) members from their section: local youth and other community members who can serve as the chief community educators about Fambul Tok. Reconciliation Committee (RC) members are also identified at the sectional level, representing a cross section of community leaders, including imams, priests, Mommy Queens (women leaders), youth leaders, etc. The RC can help mediate conflicts that might arise throughout the process, or provide special support and guidance to their community members as they work through the unhealed wounds of the war.

Both OC and RC members receive training, and then they begin the work of sensitizing the villages in the section and assisting them in preparing for the bonfire and cleansing ceremonies. (See ceremonies section for more detail.)

After the ceremonies, national and district staff meet with the communities to determine the follow-up activities they want to pursue, including establishing peace trees as a gathering spot and space for addressing conflicts and challenges as they arise in the future; forming radio listening clubs to continue to share stories of reconciliation; holding football "peace matches;" establishing women's support groups; and planting community farms. (See follow-up activities section for more detail.)

Throughout these follow-up activities, district and national support staff continue to visit the communities to check in with how the reconciliation process is going and provide support as needed. The cycle is repeated in each new section, and the overall model is repeated in each new district.

───────────

"From the beginning [of the work in a district] to the first day of a bonfire would be roughly three months.

We go in and have another consultation, go on to recruitment of district staff, and get training for the district executive. We then set them to work, and they go into those communities, meet their own people, identify hot spots, and engage them and encourage them to come together. That is [how we create] the space, and a lot of work."
—Sheku Ahmed Koroma, Fambul Tok Research And Documentation Coordinator

THE CEREMONIES

The ceremonies are unique to each community, but the general outline is the same. Drawing on the tradition of truth telling around a bonfire, communities host a bonfire in the evening, where victims and perpetrators have an opportunity to come forward, for the first time, to tell their stories and to apologize and ask for forgiveness, or to offer forgiveness. The communities then sing and dance in celebration of this open acknowledgement of, and resolution to, what happened in the war.

───────────

"This fire; eating together; eating from the same place – this brings us together, according to our culture. What happened here has actually brought us together."
—Sahr Wunde Follah, Village Chief, Kpeingbakordu

"I see it as necessary to tell my stories, so that the tension will come down. The trauma will reduce. The stress will reduce. That's why I decided last night to tell my story," said the son of the former town chief of Kongonanie (in Kailahun District), who had been brutally tortured and killed by rebels during the war. Speaking of his testimony at the bonfire the evening before, he reiterated: *"I am talking on behalf of our family. I am saying from the bottom of my heart that we have forgiven those that did the act, even though we will not forget it. I decided we should forgive [because] the act has been done, and if we say we are going to revenge, then there will be no peace in our community, there will be no development. So*

we have decided to forgive them, because when we forgive we will live together as brothers in our communities."

RENEWING TRADITION

The next day, the communities hold cleansing ceremonies that draw on a variety of traditional cleansing practices, as well as traditions of communicating with their ancestors, pouring libations, and culminating in a community feast.

Fambul Tok believes that this rich cultural heritage is a resource Sierra Leoneans can use to foster a secure peace. This is a marked departure from the experiences of many villagers who have watched for generations as outsiders offer to "improve" their culture with new influences. Fambul Tok works from the inside out, revealing the power communities have within themselves and restoring their rightful pride in their traditions.

One of those traditions has been dormant since the war. Many Sierra Leoneans believe the dead live in the land—in the riverbanks or rocks or forests across the country. For hundreds of years they courted their ancestors' support and approval with visits and offerings. The war ruptured that relationship, and for years the ancestors lay unnoticed. The ceremony that often follows a Fambul Tok bonfire reconnects villagers to their ancestors and to the heritage these rituals represent.

———————

"The ancestors were very angry with us. They were neglected. Now they're happy because we paid them some respect. With Fambul Tok we [re-]learned the value of the ancestors."
—Backarie Swarray, Town Chief, Kenewa village, Luawa chiefdom, Kailahun District

FOLLOW-UP INITIATIVES

Rooted in the understanding that reconciliation is a process and not a one-time event, Fambul Tok staff works with communities on a long-term basis, supporting reconciliation activities and local reconciliation structures until they are strong enough to support themselves.

The ceremonies are only the beginning of the reconciliation process. Following the ceremonies, the communities and Fambul Tok staff work together to identify activities to further the reconciliation process, and to build on the social capital newly created within the local community.

PEACE TREES

Fambul Tok communities select a peace tree and construct benches around it. The location functions as an ongoing meeting spot, a place to settle community or individual disputes, or simply for leisurely gatherings. Tending to these ongoing needs is the work of the Reconciliation Committees, who help parties in a conflict meet and speak freely to overcome their grievances.

These reconciliation committees mark a welcome adaptation of tradition. Before the war, resolving grievances required money. An angry party went to the chief, accused his wrongdoer, and asked the chief to resolve the dispute. He paid the chief a small sum, and the accused was summoned. If the chief found the accused to be in the wrong, he fined him, often for an amount far more than he could afford. The accused, shamed, would be forced to leave his community.

Eventually, this system of fines felt to many like extortion. When the war brought an opportunity for angry young men who had fled fines to join a rebel group, many took up weapons and fought their way back home. As Fambul Tok International (FTI) Executive Director John Caulker explains, "This is why the first attack on a village was often an attack on the chief. The Truth and Reconciliation Commission identified this as one of the root causes of the conflict."

When the reconciliation committee tackles a dispute, no money changes hands as a rule. That has allowed these committees to resolve petty griev-

ances before they turn into life-long grudges. It's a method that emerged as Fambul Tok listened closely to the communities where it works.

RADIO LISTENING CLUBS

To popularize the Fambul Tok concept nationwide and to address ongoing communal issues, Fambul Tok has facilitated the formation of radio listening clubs in each section in a district where a ceremony has been held. The clubs are open to all members of the community, but managed by youths. The community selects one day a week to discuss issues pertaining to reconciliation or development and records the discussions. The cassettes are collected regularly, and selections are broadcast by the Sierra Leone Broadcasting Service or other radio networks. In this way, the clubs provide an ongoing mechanism for public reconciliation with fellow Sierra Leoneans nationwide.

FOOTBALL FOR RECONCILIATION

To encourage all members of the community, especially youths, to be part of the reconciliation process, Fambul Tok teamed up with Play31, a US-based partner who provided the equipment and uniforms, to facilitate football matches between communities within a section that have undergone the healing ceremonies. Communities organize all the games and ensure collective participation. There are male and female games, food, and a late night disco afterwards. The footballs and jerseys are donated to the town via the chief and are accessible to all the youths in the community on an ongoing basis. In the spirit of Fambul Tok, communities work out conflicts that arise during the matches without quarreling.

COMMUNITY FARMS

To provide an ongoing opportunity for all community members, especially victims and offenders, to work together, almost all Fambul Tok communities have re-established community farms – an old tradition, but one that has been dormant since before the war.

Whether they grow cassava, or rice, the farms have become rich resources for the communities. Several villages that cultivated rice agreed that some of the harvest would be used as food for subsequent ceremonies, while the remaining seeds would be given to needy community members on loan, payable after the next season's harvest. Other communities that planted cassava have processed the harvests into garri (a popular tapioca-like food), and then sold it at the local market, the proceeds from which were used to open a community account—exemplifying one of the tools for making Fambul Tok sustainable at the local level.

Several Fambul Tok communities have reported record harvests from their community farms, often crediting the cleansing of the land that came out of the reconciliation ceremonies. Many report that for the first time since before the war, they do not have to import rice.

———————

"Gradually, gradually development is coming on. You see victims and perpetrators coming together, forming groups, going into communities, making farms – Oh, it's really wonderful! You see them coming together, doing joint labor – which is actually a sign that there is light at the end of the tunnel. Because these people were far apart, they were pointing fingers, 'It's you who did this, it's you who did that – you burned my house, you killed my father.' But now they are coming together, they're coming together to rebuild communities again. They are not talking about 'We want you to incriminate these guys,' they're talking about coming together and rebuilding their communities and the district as a whole."
—James Fallah, Journalist, Kailahun District

"When we come together, the country, or the district will develop. But if we don't come together, this community won't develop. It you don't come together, that community will not grow. For the benefit of the community you have to come together. Yesterday, we went to this community, you see people harvesting – perpetrators, victims, doing things together. That's

why their community is now changing."
—Chief Maada Alpha Ndolleh,
Kailahun Town Chief and Chairman of the Fambul
Tok District Executive in Kailahun, after spending
the day in Bunumbu.

*"[The] crime rate in Kailahun has reduced drastically.
Fambul Tok project continues to complement the ef-
forts of the Sierra Leone Police."*
—Karefa keita, former local unit commander,
Kailahun

PEACE MOTHERS

While Fambul Tok has structured in women's full
participation at all levels of program design and
implementation, we conducted a program-wide
analysis in early 2010 to make sure the program
was doing enough to meet women's unique post-
war needs. The clear outcome of this analysis was
that women, especially war widows and victims
of rape and sexual violence, felt they needed more
support after testifying at a Fambul Tok bonfire.
The follow-up activity they asked for was simply a
structured way to get together as women in their
sections —so that they could come up with activities
to do together as women, tailored to the differing
local needs of their members and sections. And thus
was born the Peace Mothers groups as a structured
follow-up activity to the Fambul Tok bonfire and
reconciliation ceremony.

To begin implementation of the program, in late
February 2010 all the Fambul Tok sections appoint-
ed women to represent them at district-level con-
sultations and trainings. Following these sessions,
the women immediately identified sectional level

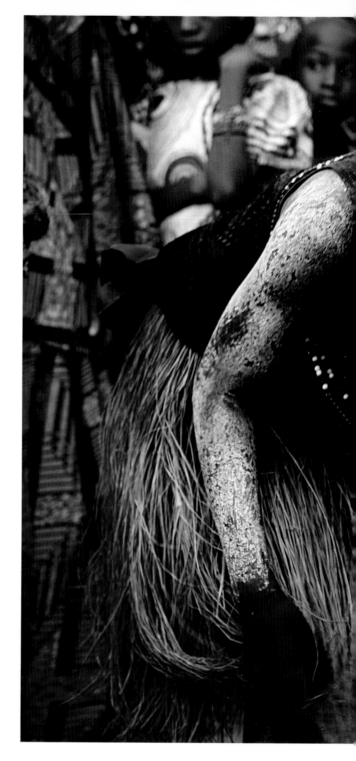

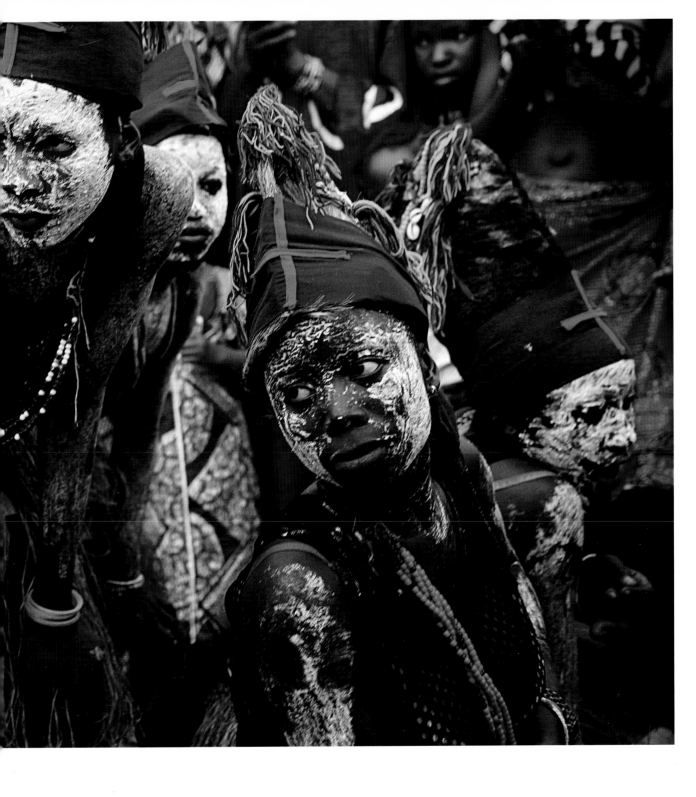

DANCERS TAKE A BREAK DURING
PRE-BONFIRE CEREMONIES IN
KONGONANIE, KAILAHUN DISTRICT.

projects to take on, ranging from building a traditional birth attendants structure to peace gardens and peace farms. These initial projects sprang into being almost instantly, with women all contributing what they could (a few cassava branch seedlings, for example) and securing tracts of land to begin clearing for the new Peace Mothers farms. Peace Mothers groups, open to all interested women in the section, are now firmly established in virtually all Fambul Tok sections—working alongside men, or sometimes even with men as supporting members of the groups themselves. In addition to the concrete projects they take on, the opportunity to gather as women creates an informal dialogue space to address issues from the war, or current challenges they are facing. This has already led to the resolution of long festering conflicts in their communities.

In addition to taking on projects like the farms, the Peace Mothers groups have also been trained in the use of tape recorders and storytelling for radio broadcasting. They are meeting regularly to share their stories related to reconciliation with their communities.

Through these radio programs, the Peace Mothers are repeatedly urging ex-combatants, and others who have fled the villages, to return to their homes and begin a process of reconciliation. These broadcasts are increasingly becoming a voice of conscience for the nation.

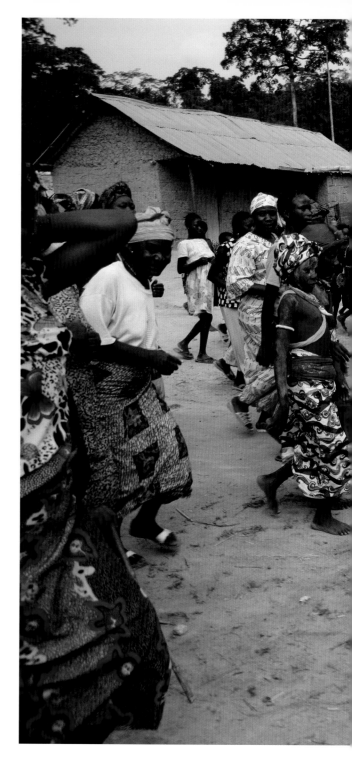

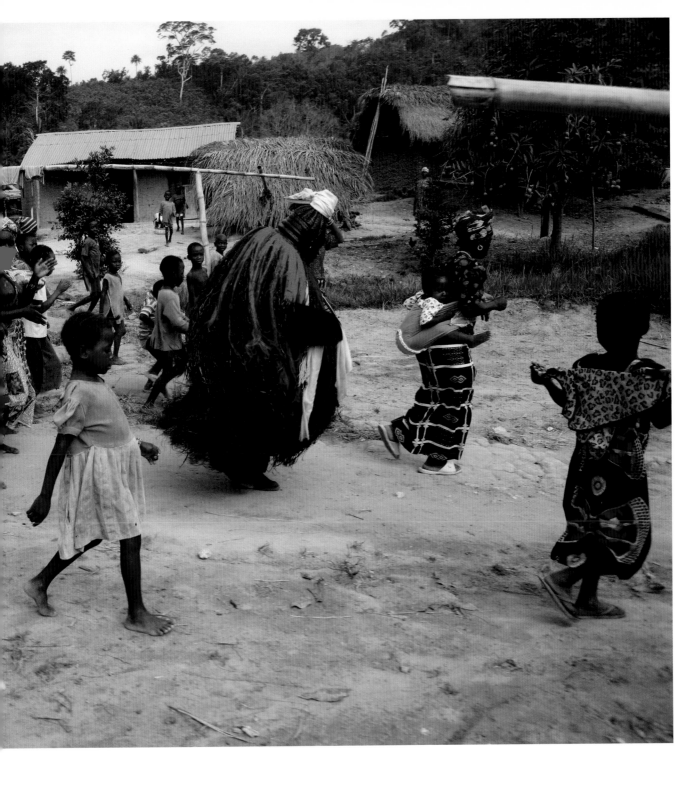

VILLAGERS CELEBRATE THE DAY
AFTER A BONFIRE IN BULOWMA,
KAILAHUN DISTRICT.

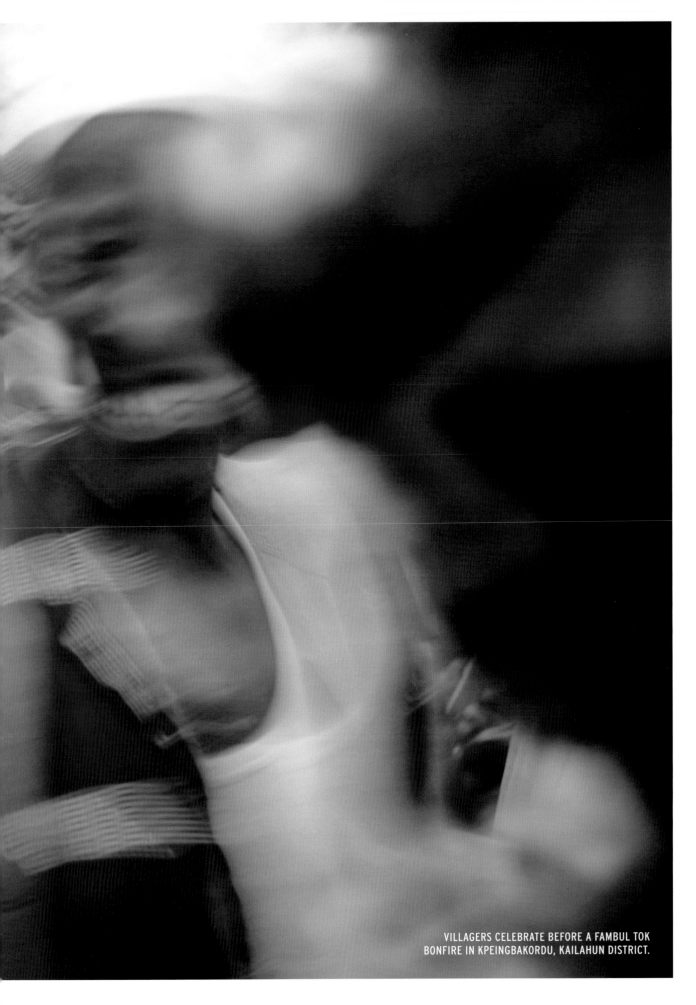

VILLAGERS CELEBRATE BEFORE A FAMBUL TOK
BONFIRE IN KPEINGBAKORDU, KAILAHUN DISTRICT.

PHOTOGRAPH BY LIBBY HOFFMAN

VILLAGERS HEADING INTO THE BUSH TO
PERFORM ANCIENT RITUALS ASKING FOR
THE BLESSING OF ANCESTORS AFTER A
FAMBUL TOK BONFIRE IN BOMARU, KAILAHUN
DISTRICT.

GOING FORWARD:
LESSONS AND IMPLICATIONS
By Libby Hoffman

After a ninety minute presentation on Fambul Tok to a group of sixth graders at The Philadelphia School, an independent grade school in the heart of Philadelphia, Pennsylvania, the twenty or so students engaged in eager conversation about the significance of what they had learned. Uppermost in their thoughts: How could people really forgive each other for such heinous things as murder, amputation, and rape? Do they have a different understanding of what "justice" means than we do? And what was the understanding of "community" that was at work in Sierra Leone that enabled them to come together in the way they did and do such extraordinary things? Very thoughtful questions for any group, I thought, but especially for a group of sixth graders. Animated conversation aside, I wasn't sure how much these twelve-year-olds would be able to connect the stories of Fambul Tok to their own lives and experiences, but I thought the exposure might at least give them something to think about.

As it turns out, the impact would be greater than I could discern at the time. A few days later, this same group of students was on a field trip, when a disruptive incident involving one of the students occurred. Instead of just sending that student to the teacher, as might typically happen, the students gathered in a circle to talk it through together with that student. They were able to resolve it satisfactorily through their dialogue, with one boy standing up at the end of the conversation and noting, "Hey! We just had our own Fambul Tok!"

The following week, the sixth grade teachers decided their class should have its own Fambul Tok, in a more intentional way. They had been plagued throughout the year by some difficult institutional and relational challenges that continued to negatively impact the learning environment, including personnel changes that were hard for the students, and instances of bullying and other forms of mistreatment among the classmates. Inspired by the kind of communities they had seen in action through Fambul Tok, the sixth grade teachers decided they could put those values into action in their classroom. Their "community conversation" ended up lasting more than two-and-a-half hours, with every child sharing the things that had been bothering them, and everyone thinking together about how to be a more supportive learning community. The teachers subsequently described the experience as among the most reward-ing educational moments they had ever had, and the students were so inspired and energized by the result that word got around the school, and other students started asking them how they might do something similar in their classes.

That's not all. Nearing the end of the deliberation process for choosing the school theme for the follow-ing year, the school's faculty had one last meeting to finalize the choice. The sixth grade teachers came to the meeting with the recommendation to put aside the other options, and instead adopt the theme of Community Wholeness, based on the experience of Fambul Tok, as the theme for the whole school for the following year. Sharing their experiences with the program, the stories they had learned, and the values that were represented, as well as discussing their own experiences as a class in living out some

(TOP) FOOD PREPARED TO OFFER TO THE ANCESTORS, IN KAILAHUN DISTRICT.

(OPPOSITE) ELDERS PREPARE TO OFFER LIBATIONS TO THE ANCESTORS IN KONGONANIE, KAILAHUN DISTRICT.

of them, these teachers made such a compelling case that the rest of the faculty agreed to adopt Community Wholeness as the school's theme for the following year.

It hardly needs pointing out that a sixth grade classroom in an independent school in Philadelphia is about as different a setting as possible from a village like the former rebel stronghold of Daabu in Kailahun District. I think it's safe to say from the events that transpired, however, that the stories and lessons of Fambul Tok meet a universal yearning for a lived experience of a healthy and whole community. What are the elements of a whole and healthy community that Fambul Tok illumines, and how does Fambul Tok help mobilize and sustain them? Surely the individual stories of forgiveness in and of themselves are enough to inspire self-reflection and even

action. But Fambul Tok is more than a series of isolated individual forgiveness stories. It represents, in part, a way of organizing that not only helps individuals to express and experience forgiveness, but also to build on those moments to create a healthy and vibrant community, and to strengthen and sustain that progress. The first element necessary for that way of organizing is clarity of shared purpose.

OUR VALUES ARE OUR WORK

Fambul Tok's stated purpose is "to create space for community owned and led reconciliation processes leading to development and sustainable peace." We can only move forward in that purpose to the degree that it's shared and embraced by the communities where we're working. Our experience has taught us

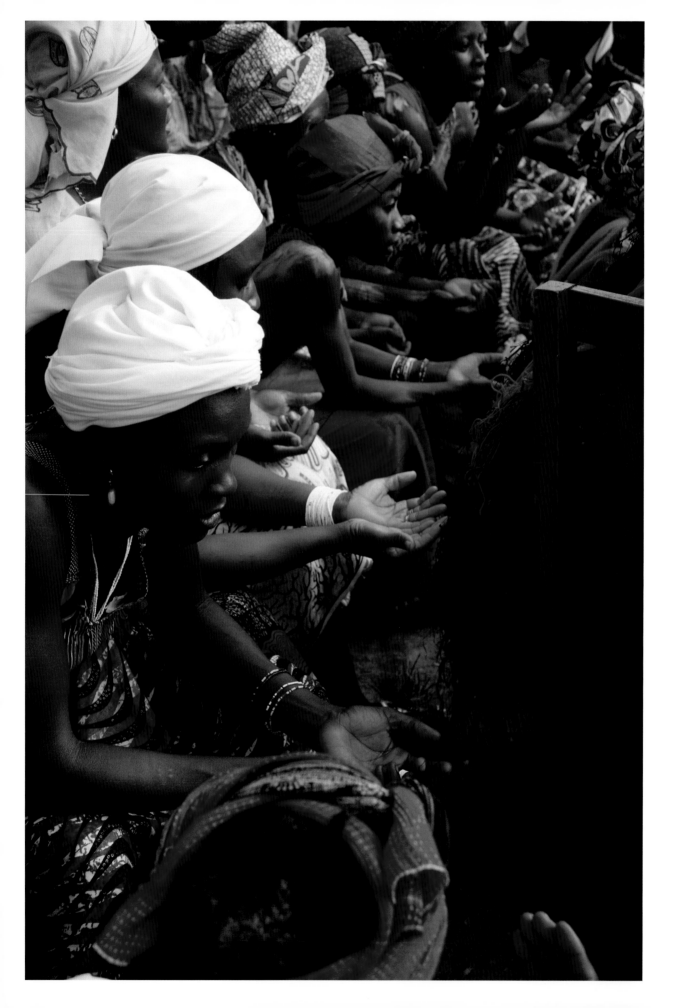

that certain values are critical to creating that space for reconciliation, so we might describe these values as our most important organizing tool.

The Fambul Tok approach is summed up in the following values:

- Being non-political and non-partisan
- Meeting people where they are, in their home communities, to listen and learn
- Walking with communities as they find their own answers
- Respect for, and revival of, traditions and culture
- Total community participation and ownership
- Transparency and accountability in relationships and activities
- Honesty and respect for all people
- Sharing experiences, stories, and lessons learned
- Restoration of dignity and the right to truth

A good bit of our work within communities is training people in our values. Our values don't inform our work—they *are* our work. We are constantly honing them, testing them against the issues we're facing on the ground, and working to live them out more fully. Having our values known, owned, and lived by the whole staff is our highest definition of organizational success. This is not instead of implementation expertise or managerial competence, but rather is primary to those things. Because we believe that the way you do something is as important as what you do, we don't separate the two.

THE ANSWERS ARE THERE

The defining element of the Fambul Tok approach isn't a certain activity set or technique, but rather a perspective—an assumption, or stated another way, a lens through which we look. "The answers are there," we say. Our fundamental operating assumption is that communities—even those most devastated by years of war and poverty, have within themselves the resources they need for their own healing and recovery within themselves. That means that our role is not to come in with answers, expertise, or programs

from the outside to try to fix, or "save," someone or something. Rather, we work to create a space for individuals and communities to see, acknowledge, and mobilize their own inherent resources for peace, the solutions that lie within. The work of creating that space is the work of Fambul Tok. It is what helps us to, in essence, (re)discover what we already know. It is natural, then, that a primary Fambul Tok value (second in emphasis only to being non-political and non-partisan) is "meeting people where they are, in their home communities, to listen and learn."

THE POWER OF ASKING

On my first trip to Kailahun, for the first Fambul Tok ceremony, I went with the staff as they visited communities, to consult about their interest in engaging in community reconciliation, and to explain Fambul Tok's approach. Over and over, what I heard most often was "No one has ever asked us what *we* want before. No one has ever asked how *we* want to reconcile." Simply being asked this question unleashed tremendous energy for, and engagement with, the process among community members. I've come to see that this is one of the lessons of Fambul Tok—the power of asking.

We don't come into communities as the experts in reconciliation, and our leadership of the process is not about us demonstrating our own expertise. Rather, it's about our insistence on the community's expertise in its own process. An insistence in asking the questions—What do you think? What do you want? What resources do you already have?—reveals the power of asking them. It reinforces the message of knowledge, experience, and power being in the hands of the community members. It helps awaken people's realization that they can lead their own community healing process.

Grounding our work in the assumption that "the answers are there" doesn't mean we don't also recognize the need for building additional knowledge and capacity. We work to provide that in appropriate ways—especially when requested by the com-

VILLAGERS JOIN IN MUSLIM AND CHRISTIAN PRAYERS THE DAY AFTER A BONFIRE CEREMONY, IN BULOWMA, KAILAHUN DISTRICT.

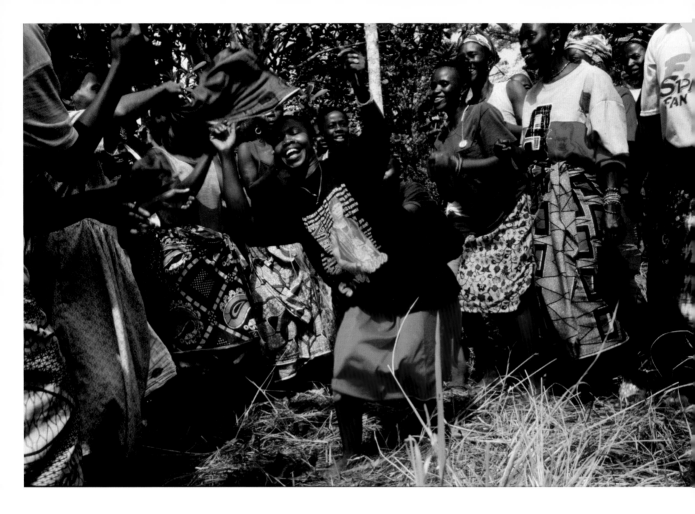

munities themselves. The training we provide to the network of community volunteers (the District Executive, Reconciliation Committees, and Outreach Teams) is a backbone of our work, offering immeasurable support to the network of thousands of volunteers who are at the forefront of the reconciliation process across Sierra Leone. The training is all for the purpose of supporting the reanimation of the networks of wisdom within the communities, and putting in place structures that help support and sustain those networks.

TOGETHER, WE'LL FIND A WAY OUT

When challenges arise, we freely admit that we rarely know the solutions beforehand. In many other settings, especially in a Western context, this would

be tantamount to admitting failure or weakness. For Fambul Tok, however, it is actually a source of strength. In emphasizing the wisdom of the community, it becomes imperative to create channels for that collective wisdom to emerge. Although time intensive, this process serves to take the sole burden of responsibility off one designated leader, and to ensure that all voices are represented and heard.

Early in the Fambul Tok program, at the beginning of our work in Kailahun District, we had a major setback. It came to light that one of the community volunteers charged with sensitizing new communities to the Fambul Tok process was stealing money from people, fraudulently telling them that participating in Fambul Tok required payment. As a major potential blow to our credibility in the delicate early stages of the work, John Caulker was distraught when he

(TOP) CELEBRATING THE RICE HARVEST ON A COMMUNITY FARM IN MADINA, KAILAHUN DISTRICT, CREATED TO BRING VICTIMS AND PERPETRATORS TOGETHER, AS A WAY TO CONTINUE BUILDING RECONCILIATION AFTER A BONFIRE CEREMONY.

(OPPOSITE) VILLAGERS CELEBRATE THE DAY AFTER A BONFIRE IN BULOWMA, KAILAHUN DISTRICT.

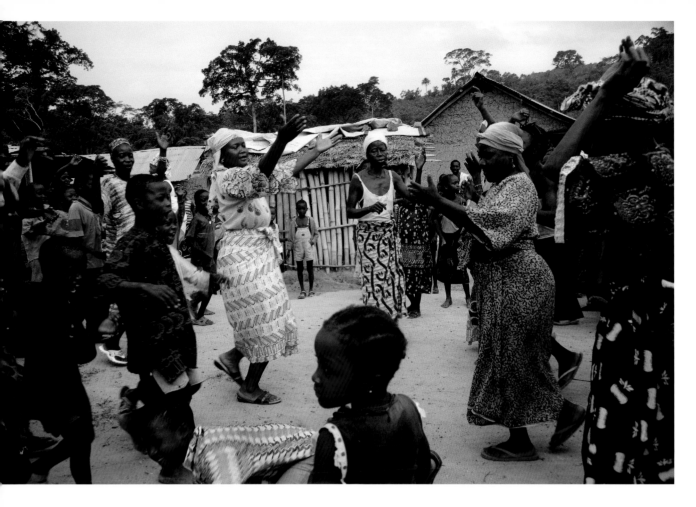

called to tell me the news. I remember feeling at a total loss as to how we should handle the situation. John's response at the time, however, set the stage for our approach, and became a defining statement for us going forward. "I don't know what to do about it," he said at the time. "But together [meaning with the communities and people affected by the theft], we'll find a way out."

DEMOCRATIZING THE SPACE

In emphasizing the finding of a way forward together, Fambul Tok is also reinforcing our stated value of total community participation and ownership. We have learned that having all voices heard is part of what helps make the space safe for the community reconciliation process. From consultation to planning, implementation, and follow-up, we emphasize the inclusion of all voices and parties: men, women, victims, perpetrators, elders, youth, Muslims, Christians, etc. This kind of inclusion can be a challenge to tradition, and it represents one of the ways the human rights lens has been an important influence on the Fambul Tok approach.

Placing all on equal footing in the Fambul Tok process has the effect of transforming social space. A woman in Daabu, for example, testified against a chief (who also happened to be District Chairman of Fambul Tok in Kailahun), something which could have led to punishment in any other setting, illustrating how the space is transformed for women specifically. These values are modeled within the Fambul Tok staff as well, with all staff participating equally in the monthly staff meetings, for example. At this

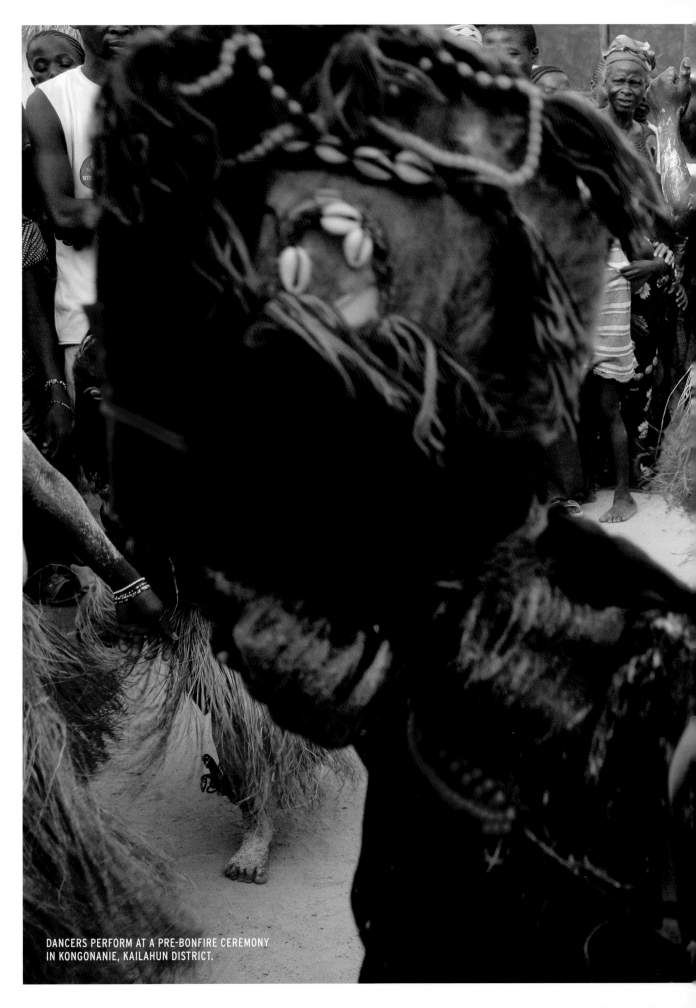

DANCERS PERFORM AT A PRE-BONFIRE CEREMONY
IN KONGONANIE, KAILAHUN DISTRICT.

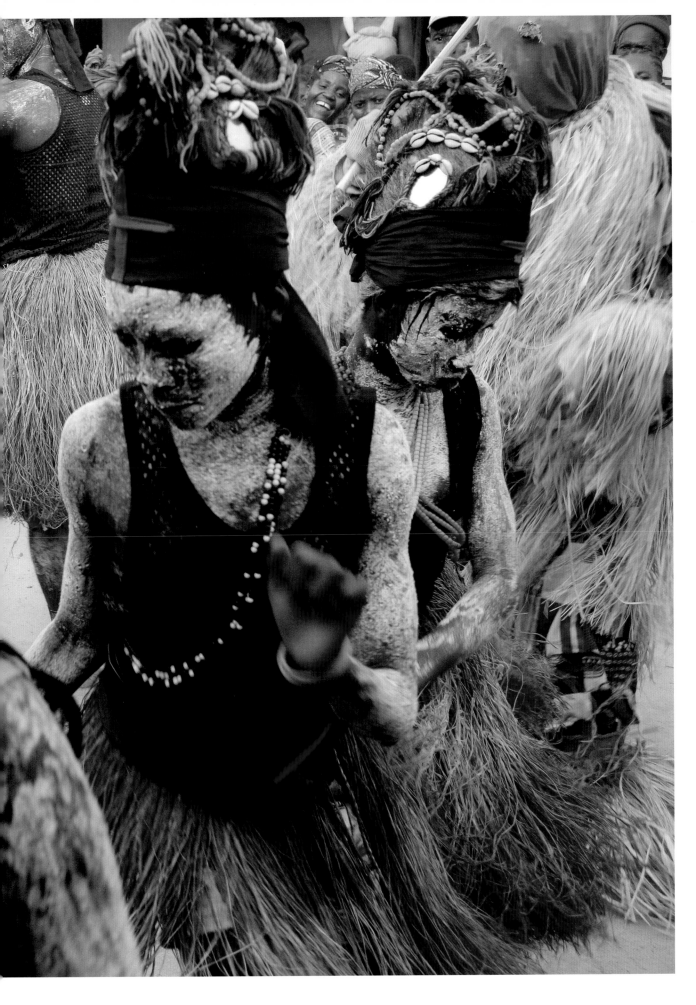

VILLAGERS WALK UP A MOUNTAIN CLEARED BY FIRE
TO CREATE A COMMUNITY FARM, AFTER A BONFIRE
CEREMONY, IN DAABU, KAILAHUN DISTRICT.

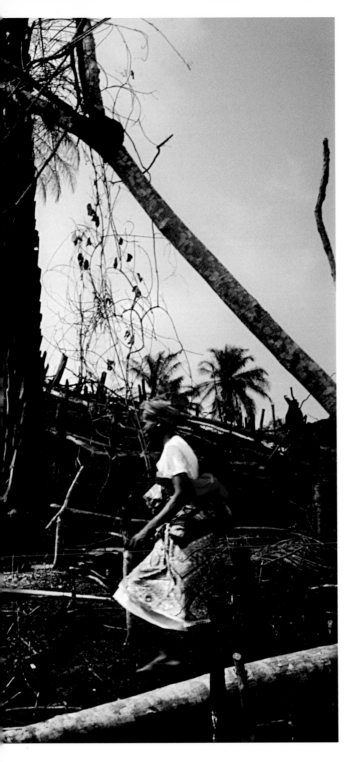

year's annual planning meeting, when the staff was asked the question, "What do you want the world to learn from Fambul Tok?" one of the first to answer the question was Mustapha Rogers, one of the program's drivers, who replied: "In reconciliation, all voices are important. Even the driver's."

Dee Hock, the founder of Visa International, and thought leader in organizational development, describes one of the key principles of effective organizations: "The governing structure must not be a chain of command, but rather a framework for dialogue, deliberation, and coordination among equals."[1] This embodies both the goals of Fambul Tok's work itself—that community reconciliation requires an ongoing framework for dialogue, deliberation, and coordination among all community members, equally represented—and of the organizational structures of Fambul Tok International. In other words, it's a continuous loop throughout the entire organization, whether at the village level (through the establishment of outreach teams and reconciliation committees), the district and national level (where the monthly all-staff meetings are crucial vehicles for information sharing and learning), or the international level (where cross-continental conversations happen at least bi-weekly, discernment teams are pulled together whenever difficult decisions need to be made or crises attended to, and in-person meetings of the senior staff happen as often as possible).

IMPACT THROUGH INDIVIDUAL CHARACTER

The rationale behind this approach isn't simply that everyone needs to be heard, as if that were an item on a checklist of things that will make an initiative successful: "OK, everyone has spoken, so we

can check that one off the list." Rather, the value of inclusiveness stems from a belief that true leadership for the whole comes from ordinary people, acting to their highest and best abilities. It is the courage and grace of ordinary people, regardless of their social or political standing, expressed in the midst of difficult circumstances, that grounds, inspires, leads, and sustains. That's what we want to help mobilize—through inviting it, building on it, and sharing the stories of it happening.

Renowned educator and former president of Dartmouth College, John Sloan Dickey, reminded his incoming students in 1946 that "the world's troubles are your troubles," a statement that is no less true now than it was in the immediate aftermath of World War II. Dickey followed this statement by declaring that "the world's worst troubles come from within men, and there is nothing wrong with the world that better human beings cannot fix." The recognition that, in the end, the call is for each of us to become a better human being rings true with us at FTI, and it

brings us back to structuring the program as best we can to help support this essential quest.

LEARNING COMMUNITIES...

We take our cue for how to structure this support from the communities themselves. The Fambul Tok bonfires illumine Sierra Leoneans' internalized understanding that the community is there to support their individual healing and progress. Seeing the power of that, we've worked to embody that concept throughout our organizational structures and by creating learning communities (our term for what Dee Hock referred to as a "framework for dialogue, deliberation, and coordination") within every segment of our work. At the organizational, local, regional, and global levels, we work to create a space and mechanism for people to actively accompany one another through sharing knowledge, building relationships of mutual care, calling forth active mutual support, and practicing collective discernment.

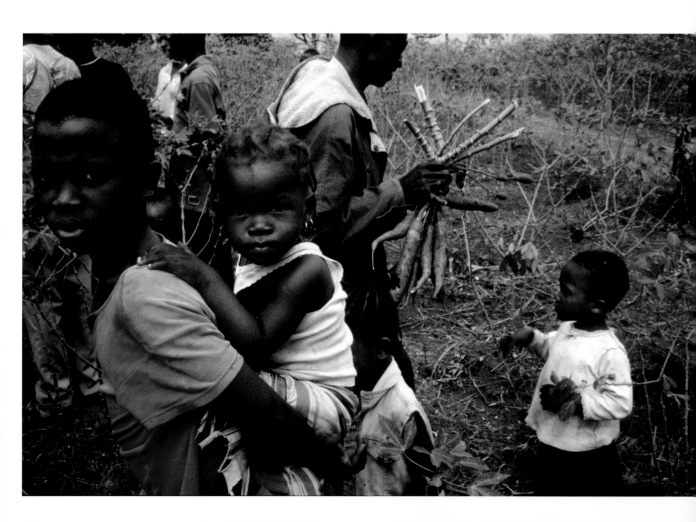

SUPPORT EMERGENT DESIGN

These learning communities become the vehicle for our practice of "emergent design." Given that Fambul Tok is responsive to on-the-ground realities, and grounded in local experience, culture, and knowledge, it is impossible to know fully beforehand just how the program will take shape in the local context. That presents a challenge in terms of organizing, especially planning and design. Embracing that challenge, we have called our process Emergent Design. This means that there are core objectives and principles in place, but a measure of flexibility in structure and implementation. This necessitates a long-term orientation, with built-in learning cycles (action, reflection, action) that allow for ongoing creation and re-creation. These learning cycles—at the local, national, and international level—are a key component of the Fambul Tok process. They are what allow us to work at the nexus of individual learning and collective progress.

AND RAPID ORGANIZATIONAL GROWTH

Working at this nexus has enabled rapid organizational development. Local grounding is foundational, obviously, but it is not enough to simply work locally. By networking within a national framework, we've been able to provide better support for each locality in turn. Sharing the lessons learned in one location illumines the way forward in others. Sharing the stories of forgiveness and reconciliation from one locale inspires in another the recognition that it is possible, as well as the commitment to doing so. Recognizing that the context for the work is national has also been crucial for some individuals—in particular perpetrators—to feel that it is truly a safe space for them to tell their story. Staff members focused at the district level have discovered that sharing their lessons and challenges with staff from other districts has provided the best form of capacity building they could ask for, since they are able to learn from other people engaged in exactly the same thing.

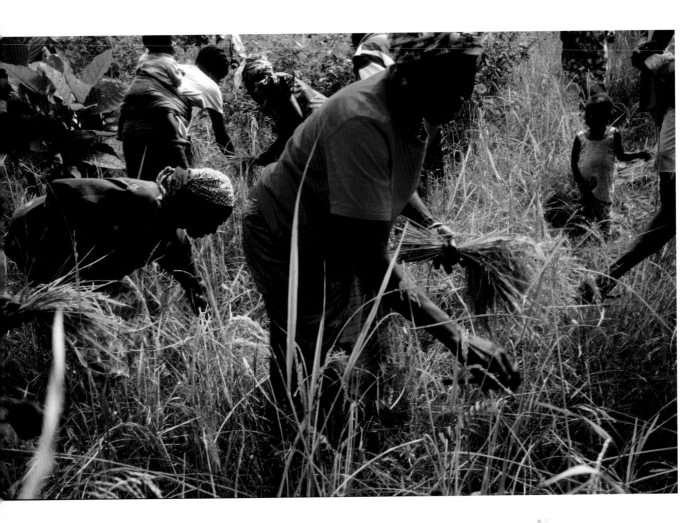

Having their stories shared with a global audience, and seeing the response to them, has in turn inspired and sustained the work of staff on the ground. Reflecting back to them stories like that of The Philadelphia School illuminates the global significance of their work that is a source of pride, as well as an incentive for continued progress.

At the nuts and bolts level, Fambul Tok has shifted from being a program to becoming its own international non-governmental organization (NGO), Fambul Tok International. As the program grew, and our stories reached a wider audience, the demand for rapid expansion within Sierra Leone and for the sharing of our model in other countries was more than we could keep up with. We knew we needed a stronger platform for moving forward if we wanted to support and sustain our growth—hence the founding of FTI.

We're now poised at a new potential phase of growth. With the release of the Fambul Tok film and the publication of this book, our stories will now reach a much wider audience. Our greatest hope is that they will inspire people to reflect on their own experiences differently, which in turn will inspire conversation and action for change.

Like at The Philadelphia School, we don't need to be the engine of that change. Some new work will no doubt happen within the auspices of FTI directly, but much will be outside of FTI. Just as learning about Fambul Tok changed those sixth graders, hearing about their actions has changed us. I am sure that as calls for action emerge from the communities impacted by our stories, new learning communities will also emerge to support and sustain them. We eagerly anticipate watching this happen.

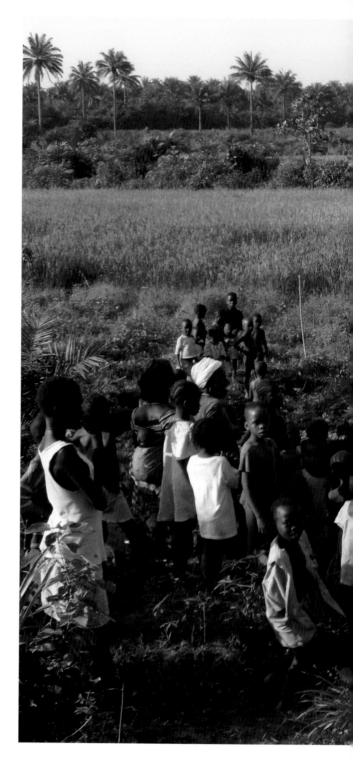

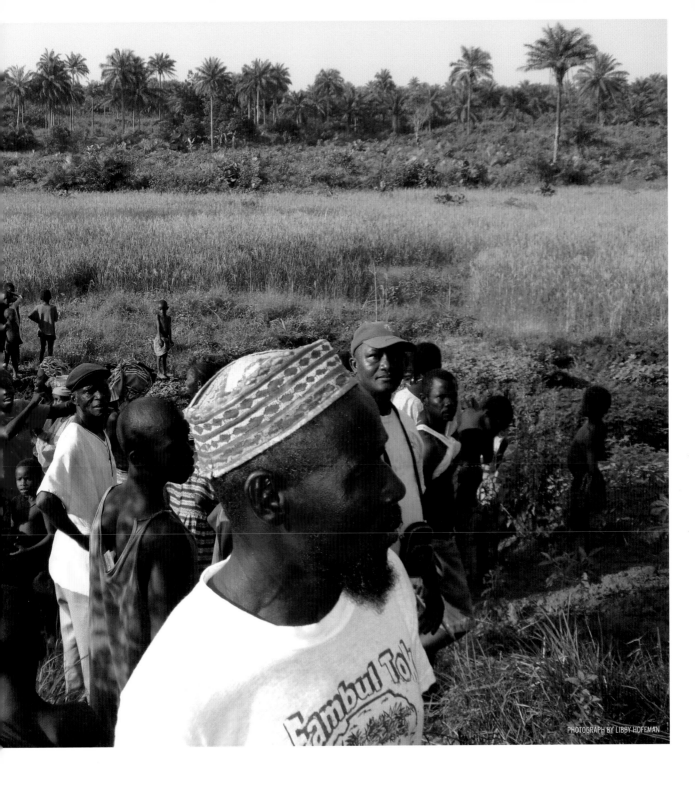

PHOTOGRAPH BY LIBBY HOFEMAN

PREVIOUS PAGES: COMMUNIY FARM HARVESTS
IN KAILAHUN DISTRICT.

COMMUNITY MEMBERS GATHER TO BEGIN
WORKING IN THEIR COMMUNITY FARM IN
MONTONKOH, MOYAMBA DISTRICT.

SIERRA LEONEANS WALK THROUGH THE COUNTRYSIDE.

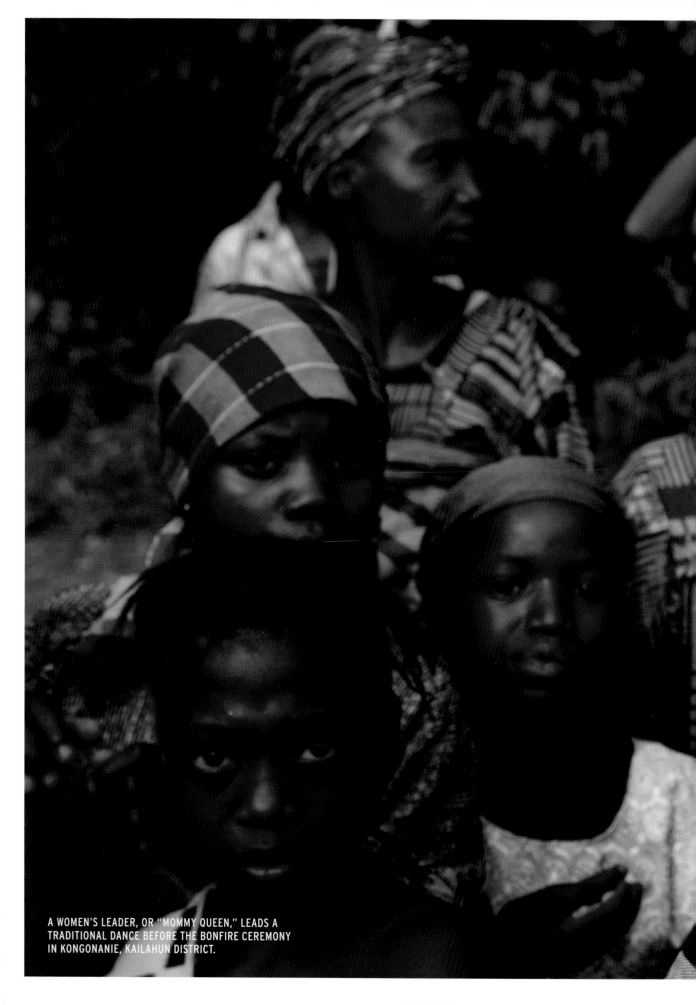

A WOMEN'S LEADER, OR "MOMMY QUEEN," LEADS A
TRADITIONAL DANCE BEFORE THE BONFIRE CEREMONY
IN KONGONANIE, KAILAHUN DISTRICT.

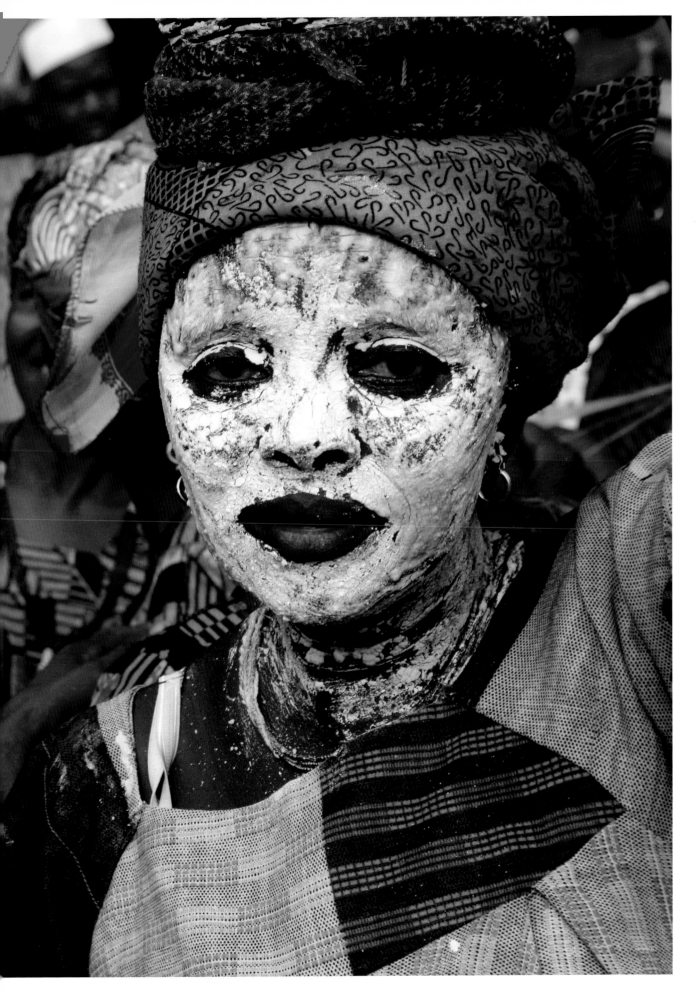

BENEDICT F. SANNOH

A distinguished lawyer, activist, and scholar, and former Chief of Human Rights Sections UNIOSIL/ UNIPSIL in Sierra Leone, he consolidated peace and promoted human rights, and also founded the Liberian Center for Law and Human Rights.

Countries emerging from conflict and yearning for peace and stability while carrying a legacy of massive human rights violations must adopt a transitional justice architecture that is comprehensive, holistic, and locally owned. Grant of amnesties, establishment of special courts to address impunity and accountability, or reparation programs to address the plight of the victims, all have various degree of success, depending on the context. In countries such as Sierra Leone, however, where there is high level of poverty, illiteracy, and entrenched cultural practices, incorporating positive cultural and traditional practices into the transitional justice architecture to address the legacy of human rights violations is a compelling necessity. Fambul Tok in Sierra Leone is a landmark initiative in this regard, using principles that can be applied both in post-conflict situations and in peacetime, consistent with the law and international standards.

There is of course a legal basis for traditional justice in international law. The UN Declaration on the Rights of Indigenous Peoples provides that indigenous people have the right to promote, develop and maintain their institutional structures and their distinctive customs, spirituality, traditions, procedures, practices, and in the cases where they exist, juridical systems or customs, in accordance with international human rights standards. Over the years, there has evolved a considerable level of interest and recognition of the role of traditional justice in peace building and peace consolidation, but it has not been expressly set forth in international instruments or in any of the mandates of the UN Security Council. The Security Council, in many of its peacekeeping mandates, has called for the strengthening of the rule of law and enhancing the justice system. This mandate must be given a dynamic interpretation to include the traditional justice system, for where it is ignored or overridden the result can be the exclusion of a large sector of society, not only from accessible justice, but also from healing and reconciliation. In fact, in the face of amnesties granted to perpetrators as part of ending the conflict, traditional and cultural rituals provide the only mechanisms to bring the victims and perpetrators together for reconciliation and healing.

The Sierra Leone civil conflict was characterized by gruesome killings, and other atrocities including mutilations, rape, destruction of villages, and indiscriminate targeting of civilians. Many of the perpetrators were civilians, including children forcibly abducted, indoctrinated, and conscripted into the warring factions. Many of the violations that took place in Sierra Leone constituted violations of the national laws of Sierra Leone, as well as war crimes, crimes against humanity, and violations of international humanitarian law. Many of the violations that took place in Sierra Leone were carried out by people against their own families, communities, and chiefdoms and districts. The war affected everyone and in a way, everyone in Sierra Leone was a victim of the conflict at the end of the war.

Constrained by the tyranny of circumstance, victims and perpetrators found themselves living together in the same towns and communities, albeit in nega-

tive peace. There were a number of cases where perpetrators have refused to return to their villages because their conscience will not allow them to do so in light of the atrocities they had committed against their own people. The need for accountability and retributive justice, to address the root causes of the conflict, the plight of the victims, to foster healing and reconciliation, and to create an enabling environment for positive peace was very evident. Unfortunately, however, very little could have been done to pursue accountability and retributive justice, even if the Government wanted to do so.

The Sierra Leone civil war virtually wiped out the formal justice system and the government lacked the capacity, in both human and material terms, to arrest, detain, investigate, charge, and prosecute all those who may have committed human rights violations during the conflict. It also would have meant incarcerating a significant portion of the productive segment of the population—since many of the perpetrators were young men and women who were also needed for the national recovery process. Such a move could also have undermined the fragile peace. Further, Sierra Leone was in a deep economic mess, that necessitated competing demands on the little resources available to the state. The budget was largely supported by donor partners, which meant that there were severe limitations on what the Government could do consistent with its post-war national recovery and stabilization plan. It would have been very difficult for the Government to use meager resources on detention facilities for hosting thousands of perpetrators.

The initial response to these challenges through the Lome Peace Agreement was not holistic and comprehensive. It granted amnesty to all former combatants for acts committed during the conflict, thereby undermining human rights, justice, and accountability. However, the Agreement was between the government and the warring faction, the Revolutionary United Front (RUF), and hence was part of the trade-off between peace and justice. Also as a result of the amnesty provisions, the Government of Sierra Leone did not put in place any domestic accountability mechanism to address the massive human rights violations committed during the conflict. This situation further deepened the wounds of the victims. Nonetheless, the Lome Agreement opened the way for reconciliation and healing by mandating the establishment of a Truth and Reconciliation Commission (TRC) as one of the main "structures for national reconciliation and the consolidation of peace" in Sierra Leone, to promote reconciliation, address impunity, and respond to the human rights needs of the victims.

However, three things changed the direction of transitional justice in Sierra Leone. First, the caveat made by the Special Representative of the Secretary General at the signing of the Lome Agreement that the amnesty provisos in the Agreement do not extend to war crimes, crimes against humanity and violations of international humanitarian law; second, the post-Lome attack on Freetown and its environs by rebel forces resulting into additional killings, burning and destruction of properties; and third, the request by then- President Kabbah to the

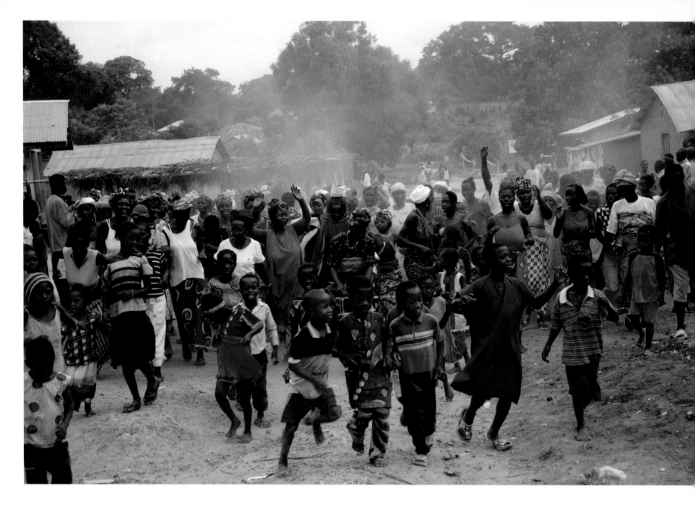

UN Secretary General to assist Sierra Leone in the prosecution of those responsible for these post-Lome atrocities. Together, these incidents led to the est̶a̶b̶lishment of the Special Court for Sierra Leone b̶y̶ ̶U̶nited Nations.

̶c̶r̶e̶ated to try those "who bear the greatest r̶e̶s̶ponsibility for the serious violations of international law and Sierra Leone law committed in the territory of Sierra Leone since November 30, 1996," the Special Court was significant as a post-conflict transitional justice mechanism, both in the area of jurisprudence and in addressing impunity. The arrest and trial of Charles Taylor, former President of Liberia, sent a clear message that no one is above the law, and that there are certain types of conduct that the international community will not condone in order to vindicate the integrity of international human rights laws, and to prevent a repetition of

such conduct. Of similar impact was the arrest and trial of the leaders of the RUF, CDF, and AFRC. But besides this, many Sierra Leoneans questioned the impact of the Court on their lives and on peace and reconciliation after the conflict. The arrest and detention of Chief Hinga Norman by the Court further exacerbated this doubt.

There are views that the phrase, "those who bear the greatest responsibility," was narrowly construed, and that there are more people who also bear responsibility for the crimes committed, who are living in the same communities with their victims, but who were never arrested or indicted. To the victims, this was not justice. It not only frustrated healing and reconciliation, but also harmonious coexistence among the people. The simultaneous establishment of the Special Court with the TRC also frustrated healing and reconciliation. A stag-

CELEBRATING AFTER THE BONFIRE, IN BULOWMA, KAILAHUN DISTRICT.

gering number of those who committed atrocities and human rights violations during the conflict and who otherwise would have appeared before the TRC, did not appear and testify for fear that, based on their testimony, they would be picked up by the Special Court and prosecuted. Given the narrow interpretation of its mandate, the Special Court issued only thirteen indictments, out of which only nine high profile cases have been prosecuted, at a cost estimated varyingly from US$200-$400 million, compared to US$3 million under the UN Peace Building Fund (PBF) for victims of the conflict.

As a result, many of those who committed atrocities and other human rights violations during the conflict have remained in the same communities with their victims, with impunity and without any atonement or accountability for their conduct. Today, nearly eight years after the Government declared "War don don," there are hundreds of perpetrators, especially in the provincial and district headquarters, who cannot even muster the courage to return to their villages and towns, some out of fear and others out of shame. Some communities are still divided along ethnic and political lines, while in others, conflicts over ownership of land and property still remain challenges. This situation called for increased effort at reconciliation, at all levels throughout the country, but there was no effective response either from the Government, the international community, civil society, or the religious organizations. The TRC in its report recommended a number of initiatives in furtherance of reconciliation, including reparations for the victims of the conflict, remembrances, public apology, memorials, commemoration ceremonies, and dates. However, the level of implementation of the recommendations has been slow, if not ineffective. Activities conducted under the UN Peace Building Fund in furtherance of reconciliation were also few and scattered and hence incapable of making any lasting impact. It is in this void that the Fambol Tok initiative has made such an impact.

The Fambol Tok initiative is a mechanism for a participatory approach to reconciliation as well as conflict resolution. The perpetrators are not coerced to return to their communities, nor are the communities coerced to receive them and accept their apologies. The outcome of their encounter is unpredictable. Managing this unpredictability through well-designed community and traditional rituals and community support programs, all rooted in respect of the cultural rights of the people of the concerned communities, characterizes the crux of the Fambol Tok initiative.

The Fambol Tok initiative recognizes and respects cultural rights as an integral part of human rights, which are universal, indivisible, and interdependent. It proceeds on the premise that the communities in the various districts in which it operates have the right to participate in the cultural life of their choice and to conduct their own cultural practices, subject to respect for human rights and fundamental freedoms. This premise is consistent with the Universal Declaration on Human Rights (UDHR) and the Universal Declaration on Cultural Diversity adopted by the General Conference of UNESCO. The positive linkage between the Fambol Tok reconciliation initiatives and the consolidation of peace in Sierra Leone cannot, therefore, be overemphasized. The initiative improves relationships between adversaries and among communities, and provides a forum to manage their conflict in a constructive, participatory, and non-violent manner. While focused on Sierra Leone at the moment, the principles adopted in bringing the victims and the perpetrators together can be replicated, not only in post-conflict situations anywhere in the world, but also in peacetime in communities or situations facing conflict. Fambol Tok is filling a void created by the inability of the government and international partners to embrace community reconciliation as a transitional justice mechanism following the conflict in furtherance of peace and stability.

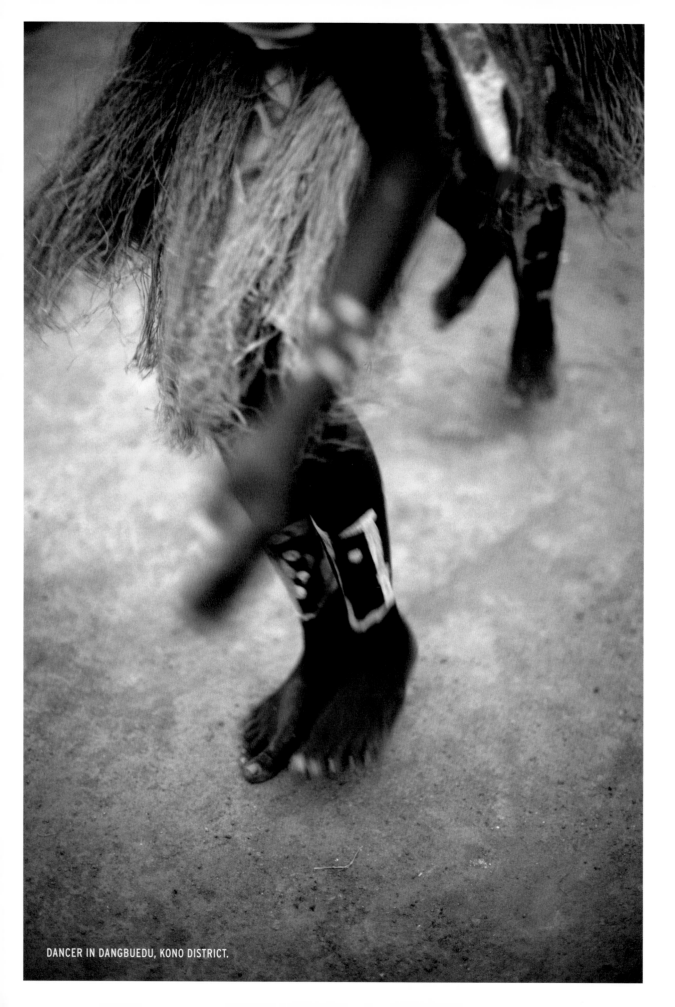

DANCER IN DANGBUEDU, KONO DISTRICT.

PRE-COLONIAL ERA

Sierra Leone's earliest known inhabitants live in small fishing and farming communities along the Atlantic Coast and scattered settlements in the interior. In 1462, Portuguese explorers make their first contact with the coastal inhabitants and name the country "Sierra Leone."

COLONIAL ERA

1787
British philanthropists and slave trade abolitionists establish a settlement in Freetown for rescued and repatriated slaves.

1808
Freetown made a British Crown Colony.

1821
Freetown made the seat of government for British territories in West Africa.

1827
The Fourah Bay College established. For more than a century, it is the only European-style university in western Sub-Saharan Africa.

1896
Britain establishes a protectorate over the Freetown hinterland.

1898
Bai Bureh, a Temne Chief, with support from other prominent chiefs including the powerful Kissi Chief, Kai Londo, and the Limba Chief, Almamy Suluku, leads a rebellion (The Hut Tax War) against British rule after the British impose a tax on "huts" (dwellings). The tax is generally regarded by the native chiefs as an attack on their authority.

1924
Sierra Leone is divided into a Colony and a Protectorate, with different political systems constitutionally defined for each.

1947
Antagonism between the two entities escalates to a heated debate when proposals are introduced to provide for a single political system for both the Colony and the Protectorate.

1951
Milton Margai oversees the drafting of a new constitution, which unites the separate Colonial and Protectorate legislatures and—most importantly—provides a framework for decolonization. The new constitution ensures Sierra Leone becomes a parliamentary system within the Commonwealth of Nations.

1954
Sierra Leone is granted local ministerial powers. Sir Milton Margai, the leader of the Sierra Leone People's Party (SLPP), is elected Chief Minister under the new constitution.

1957
Sierra Leone holds its first parliamentary election. The SLPP, then the most popular political party in the colony, wins the vast majority of seats in Parliament. Margai is also re-elected as Chief Minister by a landslide.

AN INDEPENDENT NATION

1961
Sierra Leone gains independence from Britain, and Freetown is made its official capital city.

1967
Siaka Stevens is sworn in as Sierra Leone's third prime minister on the 17th of May. Later, a military coup led by Brigadier David Lansana overthrows the elected All People's Congress (APC) government. Lansana is later executed for treason in 1975.

1968
March: A group of senior army officers, the National Reformation Council (NRC), led by Brigadier Andrew Juxon-Smith, seize control of the government, arrest Lansana,

and suspend the constitution. Martial law is maintained.

April: The NRC is overthrown by a third group of senior army officers, led by Brigadier General John Amadu Bangura, who call themselves the Anti-Corruption Revolutionary Movement (ACRM). Siaka Stevens is reinstated as Prime Minister.

1971
Sierra Leone is declared a Republic and Siaka Stevens is subsequently sworn in as the first Executive President of the Republic of Sierra Leone.

1973
President Stevens signs a treaty with President William Tolbert of Liberia establishing the Mano River Union, to facilitate trade between Sierra Leone and Liberia, with Guinea joining in 1980 under president Ahmed Sékou Touré.

1975
Sierra Leone joins the Economic Community of West African States (ECOWAS).

1978
A new constitution establishing Sierra Leone as a one-party state, with the APC as the sole legal party, is adopted through a referendum. SLPP members of Parliament join the APC.

1980
Stevens spends borrowed millions on hosting an Organization of African Unity conference, contributing to the country's mounting debt.

1983
The Ndogboyosoi (bush devil) war between APC and SLPP supporters racks Pujehun District in southern Sierra Leone.

1985
Major General Joseph Saidu Momoh, commander of the Armed Forces, and Stevens' choice to succeed him, is sworn in as president on the 28th of November, with Francis Minah as vice president. President Momoh is subsequently often described as a "well-meaning drunken womanizer," with few political or leadership skills.

DEMOCRACY AND WAR IN SIERRA LEONE

1990
Due to mounting pressure from both within and outside the country for political and economic reform, a constitutional review commission is established to review the 1978 one-party constitution.

1991
March: 100 Sierra Leonean dissidents (mostly university students), Liberian fighters loyal to Charles Taylor, and a small number of mercenary fighters from Burkina Faso invade the country from Bomaru, in the Kailahun district. Another group enter from the Mano River Bridge linking Liberia and Sierra Leone, in the Pujehun District. Foday Sankoh, a former army corporal, leads the invasion to overthrow the Momoh-led APC government under the banner of the Revolutionary United Front (RUF). With the RUF incursion into Sierra Leone, rather than targeting the central government in Freetown, ordinary people such as farmers, villagers, and alluvial miners are deliberately tortured, maimed, abused, and uprooted from their livelihoods and surroundings. As the war expands to other locations the rebellion worsens, and civilian casualties mount.

May: Momoh, fearful of dissatisfaction in the Sierra Leone Army, and the threat the rebel RUF incursion presents to internal security, appeals to Britain for their intervention. With no help forthcoming from Britain, the government seeks the help of mercenary agencies. Morale in the army is very low, and as it becomes clear that the army is collaborating with the rebel group.

1991
October: A constitution re-establishing a multi-party system is approved by sixty percent of voters through a referendum. Elections are scheduled for May 1992.

1992
April: Junior army officers, led by 26 year-old Captain Valentine Strasser, stage a coup and overthrow the Momoh-led APC government, on the pretext of delivering a démarche to Momoh's office in Freetown about sinking army morale. These officers establish the National Provisional Ruling Council (NPRC) and suspend the 1991 Constitution. Momoh flees to Guinea.

Strasser is installed as head of state and appoints Solomon Musa, an even younger officer, as his number two. During his tenure as head of state he is often called 'The Redeemer' – as he was seen to be taking concrete steps to establish commissions mandated to investigate the activities of ministers, executive heads of ministries, and parastatals in the Momoh-led government. He replaces most of the

military officers in his cabinet with civilian appointees, presumably to ensure the military members of the government concentrate on pursuing the war to its conclusion. Initial attempts to negotiate with RUF leader Sankoh fail, as Sankoh's preconditions are deemed unacceptable to the NPRC government.

1992

Strasser dismisses Musa, and replaces him with Lieutenant Julius Maada Bio. Musa seeks refuge in the Nigerian Embassy and is then granted asylum in the UK.

1993

Strasser announces a plan to return the government to civilian rule by 1996. Dr James Jonah, by then Deputy Secretary General of the United Nations (UN), is appointed by the NPRC junta as the chairman of the new Interim National Electoral Commission (INEC), which is in charge of the demarcation of electoral boundaries, and voter registration.

1994

The NPRC junta proposes a change in the age restriction clause in the 1991 Sierra Leone constitution, which states that only Sierra Leoneans over the age of 40 are eligible for the presidency, thus excluding Strasser and others in the NPRC.

Strasser's government initiates a recruitment drive to increase the strength of the army. The army bloats from 5000 to 12,000 in a year, mainly by recruiting poorly-educated youths from city streets, including orphans and abandoned children as young as twelve years old.

October: Public and international assistance to the NPRC dissipates as the young soldiers indulge in drugs, corruption, and abuses against opponents and civilians.

February: Well-organized groups of RUF fighters advance towards Freetown, despite the presence of 2000 Nigerian soldiers stationed in the capital. Due to the ineffectiveness of the Sierra Leone Army, the government increasingly has to depend on foreign troops for direct intervention, including the services of a group of former British Army Gurkhas (the Gurkha Security Group). With the capture of Western hostages by the RUF, the rebel war is covered extensively internationally. When the Gurkhas, despite their fearsome reputation, are successfully ambushed by the RUF and their Canadian commander Colonel Robert MacKenzie killed in the process, they depart from Sierra Leone early.

March: A number of expatriates and Sierra Leoneans taken hostage by the RUF are released to the International Committee of the Red Cross through the intervention of International Alert (IA). IA draws on its access to the RUF to become a key factor in subsequent peace negotiations along with regional diplomats, the OAU, the UN, and the Commonwealth.

May: Strasser seeks help from a South African private security agency, Executive Outcomes (EO), when the RUF come to within 20 miles of Freetown. EO is a security agency run by Eeben Barlow, formerly of the 32nd Battalion of the South African Special Forces, which was active in South Africa's

1980s destabilization policy against its neighbors and covert operations in Angola and Mozambique. EO, in collaboration with Nigerian and Ghanaian troops, forestall the rebel advancement into the city, despite their pincer-movement attack with thousands of well-armed fighters, after a bloody fight on the outskirts of Freetown. The RUF control most of the mining operations in the country, crippling the government's revenue base.

December: EO expands its operations into rural Sierra Leone, re-taking the diamond mining areas by the end of 1995, and providing security for returnees displaced from these locations. EO begins to co-operate with the Kamajors, a rural militia composed of Mendes – the country's largest ethnic group – under the command of Samuel Hinga Norman, that provide security in places where a government-approved security apparatus is absent. They are viewed as a powerful fighting force with mystical power and wield great political power.

1996

January: EO retakes the Sierra Rutile mine, although the plant had already been looted by an SLA contingent led by Johnny Paul Koroma. In concert with Nigerian troops, EO uproots the RUF from its base in the Kangari Hills. With the RUF badly beaten, its leader, Foday Sankoh, calls for peace negotiations with the NPRC government. Under immense pressure from Britain and the US, the NPRC government is forced to schedule elections for the 25th of February.

Strasser is ousted in a military coup led by Brigadier Julius Maada Bio,

whose sister, Agnes Deen Jalloh, is a senior member of the rebel RUF. On the advice of Nigerian military leader General Sani Abacha, Maada Bio tries to postpone the elections. Women, especially those in support of the "Election Before Peace" campaign, march through Freetown to oppose this move, suspecting a conspiracy between Maada Bio and local politicians to hold on to power. Following these massive street demonstrations, a National Consultative Conference is held. Political leaders, traditional chiefs, labor organizations, women's groups, and religious organizations, encouraged by the UK and US governments, press for elections to be held in February and for the NPRC to pursue a negotiated settlement with the RUF.

February: Presidential and legislative elections are held, monitored by international observers. These elections are contested by thirteen political parties, with none of the presidential candidates getting the required percentage of votes in the first round of the polls.

March: In the second round of voting, Ahmad Tejan Kabbah, leader of the southern-based Sierra Leonean People's Party, is declared the winner after gaining 59.9 per cent of votes, over John Karefa-Smart, leader of the northern-based United National People's Party. President Kabbah, a former UN diplomat who had been out of the country for many years, continues to retain the services of foreign security companies: EO, Britain's Defence Systems Limited, and local affiliates such as Teleservices and Lifeguard (owned by EO director Barlow). Kabbah appoints the Kamajor leader Hinga Norman as Deputy Minister of Defence.

July: Criticism mounts at the slow pace of reform under Kabbah. His decision to use the Kamajors as a de facto Presidential guard makes him unpopular with the army. The situation degenerates to the point where the army divides along the lines of loyalist and pro-rebel factions. The situation is made worse when Kabbah announces a retraining program and dramatic reduction of the army.

August: EO defeats the RUF in its southern stronghold at the Kangari Hills. The RUF proposes negotiations with Freetown and agrees to recognize Kabbah's government, on the condition that EO troops are withdrawn. London-based International Alert acts as the mediator for the RUF, handing out copies of Sankoh's ideological pamphlets to puzzled journalists, and organizes talks between the RUF and Kabbah in neighboring Côte d'Ivoire.

September: Public outrage erupts over the cost of the contract that the Kabbah government had signed with EO, estimated at $1.8 million USD a month for the services of less than a hundred personnel, along with two Russian Mi-17 helicopters and logistics. Freetown politicians accuse EO of exacerbating the civil conflict, inserting charges that the government was unaware of, and forcing the government to make payments over and above their initially agreed monthly fees. The International Monetary Fund encourages the government to renegotiate the contract with EO and improve accountability in the mining sector. Kabbah then renegotiates the EO contract, reducing the amount to $1.2 million USD monthly. Independent sources, however, report that the government still owes EO $30 million USD in arrears.

November: A peace agreement between the Kabbah government and the RUF is signed in Abidjan.

1997
January: EO departs Sierra Leone, to be replaced by their affiliate, Lifeguard.

The Kabbah government establishes a power-sharing multi-party cabinet, and the RUF is appointed to manage peace, reconciliation, and demobilization commissions. Kabbah's administration is damaged by indecision and poor handling of the military. Upon announcing that a Nigerian-led security investigation has pinpointed members of the previous Maada Bio government as coup plotters, RUF leader Sankoh, who had flown to Nigeria on a government business, is arrested on arrival.

May: The SLPP government is overthrown in a coup by the Armed Forces Revolutionary Council (AFRC), led by Johnny Paul Koroma. Koroma suspends the constitution, bans demonstrations, and abolishes political parties. Days of looting follow the coup, as soldiers commandeer cars and persecute members of the SLPP, including the former Minister of Finance who was arrested and tortured. Surrounded by Nigerian military advisors, security men, and a group of Sierra Leonean politicians of dubious credibility, Kabbah is described as a "rabbit caught in a car's headlights" at the time of the coup.

An attempt by Nigerian troops to oust the Koroma junta ends in fiasco after junta forces trap Nigerian troops and other foreigners at the Mammy Yoko Hotel. Some South African soldiers working with Lifeguard fight alongside the Nigerians, trying to force back the junta soldiers. The British High Commissioner, Peter Penfold, is instrumental in negotiating the release of the trapped foreigners.

Foday Sankoh gives interviews to the BBC while under house arrest in Abuja, praising the overthrow of Kabbah. Koroma declares Sankoh the leader of the coup, and Nigerian officials move Sankoh from the Sheraton Hotel to a local security installation.

June: Koroma extends an invitation to the RUF to join his junta. RUF fighters heed his call call, marching into Freetown and adopting the name "The People's Army."

July: Sierra Leone is suspended from the Commonwealth. Kabbah has discussions with Indian-born Thai banker Rakesh Saxena who offers to provide up to $10 million to support a counter-coup, in return for diamond mining concessions. Saxena contacts Colonel Tim Spicer, head of private security company Sandline International, and commissions an intelligence assessment of the military and political situation in Sierra Leone.

A four-nation committee of Nigeria, Côte d'Ivoire, Guinea and Ghana is formed by the sub-regional Economic Community of West African States (ECOWAS) to negotiate a return to constitutional rule with the Koroma junta. The ECOWAS committee imposes an embargo on all military supplies to the Koroma junta; the Nigerian navy mounts a naval blockade in Freetown and directs the junta to clear all cargo ships with ECOWAS officials. The UN Security Council condemns the coup and endorses ECOWAS measures to resolve the crisis through diplomatic means and sanctions. UN Resolution UNSC1132 is passed, imposing a ban on arms shipments to all parties in Sierra Leone. Sandline nonetheless supplies "logistical support," including rifles, to Kabbah allies. Nigeria moves 4,000 troops from its operations in Liberia to Freetown.

August: A number of businessmen approach Kabbah with offers to finance an operation to reinstate his government. They include Chief Executive of American Mineral Fields (AMF) Jean-Raymond Boulle, whose company played a key role in financing the successful rebellion against Mobutu Sese Seko in Zaïre earlier in 1997. Other companies include Defence Systems Limited and Sandline, both based in London and with strong links to the British Foreign Office and Ministry of Defence.

September: Kabbah receives diplomatic support from the British government, driven by enthusiasm to return Kabbah and a constitutional government to power in Sierra Leone but also wanting to curtail Nigeria's General Abacha's intervention and involvement in the restoration of a democratically elected Sierra Leonean government.

October: Nigeria's Foreign Minister Tom Ikimi steps up his country's diplomatic role after the Nigerian Navy and Air Force tighten the embargo on Freetown. The Koroma junta accuses the Nigerian Air Force of bombing civilian targets. Liberian soldiers detain a plane at Spriggs Payne Airport, Monrovia, found carrying several South African mercenaries working for EO, Kamajor militiamen, and assorted arms and military equipment. After pressure from Nigerian troops in the ECOWAS peacekeeping operation in the country, Liberian officials release the plane.

Peace negotiations between the Koroma junta and ECOWAS on the 23rd conclude with a promise by Koroma's ministers that the junta will hand over power to a civilian government by the 22nd of April 1998. Nigeria lauds this as a great diplomatic breakthrough and requests an invitation to the Commonwealth Conference in Edinburgh on the 24th-27th October, Nigeria's membership of the Commonwealth having been suspended in November 1995 after its military government executed Ken Saro-Wiwa and eight other Ogoni activists. Kabbah attends this Commonwealth meeting, but it is evident that most officials at the meeting have no knowledge of the Nigerian-brokered deal with Koroma and are skeptical about its viability.

November: Several plans for the ousting of the Koroma-led junta are floated. Efforts are made to involve South African officials in the plan and win the support of the African Union (previously called the Organization for African Unity). A secret mission to South Africa ends in fiasco after a Nigerian plane and its crew are impounded on landing at a military airbase near Pretoria. South Africa declines a request to provide logistics

and air-support for a Nigerian operation to oust Koroma.

December: Sandline International presents a plan to Kabbah and financier Boulle for the ousting of Koroma. Boulle remains unconvinced. Rakesh Saxena, however, makes a definitive offer to finance the overthrow of Koroma, paying $1.5 million to Sandline as the first installment for the operation. The second installment does not materialize, after Canadian police arrest him in Vancouver for possession of a forged Yugoslavian passport.

1998

February: A Nigerian-backed offensive by the Kamajors begins in southeast Sierra Leone, with Sandline providing intelligence and logistics support. Liberian president Charles Taylor accuses Nigerian-led ECOMOG (a military coalition of ECOWAS states) troops of transporting South African mercenaries across his territory. The ECOWAS Committee of Four, led by Tom Ikimi, travels to New York to brief the UN Security Council about progress on negotiations with Koroma. Questioned about reports of a Nigerian led-offensive against the Koroma junta, Ikimi dismisses the fighting as isolated skirmishes. No attempt is made to inform the Security Council of the operation. Within days ECOMOG troops launch an assault on Freetown and drive rebels out of the city.

March: Kabbah makes a triumphant return to Freetown amid scenes of public rejoicing.

1999

January: Rebels backing RUF leader Sankoh seize parts of Freetown from ECOMOG. After weeks of bitter fighting the RUF are eventually driven out, leaving behind 5000 dead and a devastated city. Sankoh is idolized as a lion by his supporters.

May: The UN intervenes, and a ceasefire agreement is negotiated in Freetown with cautious optimism, amid hopes that eight years of civil war may soon be over.

July: Six weeks of talks in the Togolese capital, Lomé, result in a peace agreement, under which the rebel leaders are given cabinet positions in an SLPP-led government, with assurances that they will not be prosecuted for atrocities and abuses perpetrated during the war.

November/December: UN troops arrive to supervise and monitor the implementation of the peace agreement. RUF second-in-command Sam Bockarie vehemently opposes this intervention. ECOMOG troops are attacked outside of Freetown.

2000

April/May: UN forces come under attack in the east of Sierra Leone, with several hundred UN troops abducted and taken as hostage.

May: Rebels closed in on Freetown. 800 British paratroopers are sent to Freetown to evacuate British citizens and to help secure the airport for UN peacekeepers. Foday Sankoh is captured.

August: Eleven British soldiers are taken hostage by renegade militia group the West Side Boys. British forces later mount an operation to rescue the remaining hostages.

2001

January: The government postpones presidential and parliamentary elections planned for February and March, because of continued insecurity.

March: UN troops began to deploy peacefully for the first time in rebel-held territories.

May: The disarmament of rebels commences, with a British-trained Sierra Leonean army deployed in rebel-held areas.

THE POST-CONFLICT ERA

2002

January: The Sierra Leone Civil War is declared over. The UN mission announces the completion of the disarmament process, 45,000 combatants having gone through this process. The government and UN agree to set up a war crimes court and Truth and Reconciliation Commission (TRC).

May: Kabbah wins the election in a landslide. The SLPP secure a majority in parliament.

July: British troops leave Sierra Leone after their two-year mission to help end the civil war.

2003

July: RUF leader Foday Sankoh dies of natural causes while waiting to be tried by the war crimes court.

August: Kabbah tells the TRC he was not involved in the operations of pro-government militias during the war.

2004

February: Disarmament and rehabilitation of more than 70,000 civil war combatants is officially completed.

March: The war crimes tribunal opens a courthouse to try senior militia

leaders from both sides of the war.

May: The first local elections held in more than three decades commence.

June: The special court commences.

September: The UN hands over control of security in Freetown to local forces.

2005

The UN Security Council authorizes the opening of a UN assistance mission in Sierra Leone in 2006, after the departure of the peacekeeping mission in December. When the last peacekeeping troops depart Sierra Leone, it marks the end of a five-year mission to restore order.

The TRC Report is released, comprised of four books of almost 2000 pages.

2006

Liberian ex-president Charles Taylor is arrested in Nigeria and handed over to the war crimes tribunal in Sierra Leone, which had indicted him.

December: Kabbah announces that 90 per cent of Sierra Leone's $1.6 billion USD debt has been written off after negotiations with international creditors.

2007

June: Charles Taylor's war crimes trial begins in The Hague, where he stands accused of instigating atrocities in Sierra Leone. Sierra Leone's special war crimes court in Freetown delivers its first verdicts, finding three militia leaders guilty.

August: Presidential and parliamentary elections are conducted. Ernest Bai Koroma wins the presidency and his APC, formerly in opposition, become the majority in parliament.

December: Fambul Tok launches in Sierra Leone with district-level consultations across the country.

2008

January: Charles Taylor's war crimes trial resumes after a six-month delay.

March: The first Fambul Tok reconciliation ceremony takes place in Bomaru, Kailahun District, on the anniversary of the day the war began there, March 23.

August: Local elections are marred by violence between the supporters of the SLPP and APC.

2009

April: Three former senior leaders of the RUF are sentenced to long jail terms for civil war atrocities.

September: The UN Security Council unanimously adopts Resolution 1886, extending the mandate of the UN Integrated Peacebuilding Office in Sierra Leone (UNIPSIL) until the 30th September 2010.

October: The Special Court winds down after seven years of investigating civil war atrocities. It holds its final hearing in Freetown, with judges upholding the convictions of three former RUF leaders. Charles Taylor's trial continues in The Hague.

The Secretary-General for Peace-building Support, Judy Cheng-Hopkins, visits Sierra Leone on the 22nd and 23rd. Sierra Leone is the first nation to be placed on the agenda of the UN Peacebuilding Commission (PBC).

November: Eight people convicted by the court are transferred to a facility constructed for the International Criminal Tribunal for Rwanda, because prison facilities in Sierra Leone do not meet international standards for imprisoning people convicted by international tribunals.

2010

April: Sierra Leone's government launches a major initiative on the 27th to make health care free for pregnant women and children. The program abolishes fees at public hospitals and health clinics across the country for a set of basic health services for all pregnant and nursing mothers and every child under five years old.

June: The UN Secretary-General, Ban Ki-moon, visits Sierra Leone, where he highlights the success of the country in consolidating peace. President Koroma launches the "Sierra Leone National Action Plan (SiL NAP) on United Nations Security Council Resolutions 1325 and 1820."

2011

March: At the anniversary of the start of Fambul Tok in Sierra Leone, Fambul Tok unrolls an international conversation on reconciliation with the launch of the Fambul Tok book and *Fambul Tok* (the film), with screenings and discussions in over 100 communities in Sierra Leone, as well as a worldwide effort of education on the lessons of peacemaking embodied in Fambul Tok.

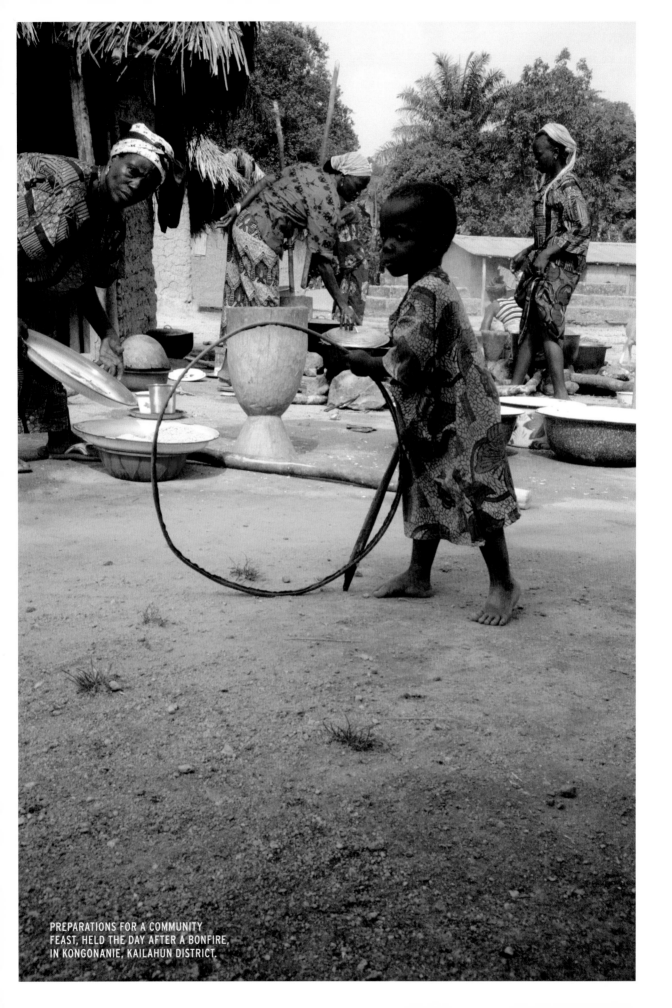

PREPARATIONS FOR A COMMUNITY
FEAST, HELD THE DAY AFTER A BONFIRE,
IN KONGONANIE, KAILAHUN DISTRICT.

The following overview of the Truth and Reconciliation Commission of Sierra Leone is based on the introductory chapters from the TRC Report: A Secondary School Version, *published in Sierra Leone in 2005 by the TRC Working Group, available at: www. sierra-leone.org/Text_book_Sierra_Leone.pdf*

After the Lomé Peace Agreement, negotiated in July 1999, marked the beginning of the end of the near-decade of violence between the government and rebel forces in Sierra Leone's civil war, there was a need for Sierra Leoneans to confront the past; to understand what caused people to turn on each other with such brutality, abandoning strong traditions of community and ignoring long-cherished customs and taboos. The Peace Agreement recognized a need for Sierra Leoneans to find out who was behind the atrocities, express suffering, tell stories about their experiences and be heard, and work to reconcile with former enemies to begin the healing process, providing for the establishment of a Truth and Reconciliation Commission (TRC).

The Sierra Leone parliament then enshrined the provision of a TRC into law with the Truth and Reconciliation Act, 2000, with the act itself stating:

"The object for which the Commission is established is to create an impartial historical record of violations and abuses of human rights and international humanitarian law related to the armed conflict in Sierra Leone, from the beginning of the Conflict in 1991 to the signing of the Lomé Peace Agreement; to address impunity, to respond to the needs of the victims, to promote healing and reconciliation and to prevent a repetition of the violations and abuses suffered."

The TRC subsequently began in July 2002, both to find out the truth about the causes and actions of the war and to make recommendations to ensure it never happens again, by collecting information about the recent history of Sierra Leone, the war, and its participants, causes, and consequences.

While most truth commissions are set up as alternatives to criminal prosecution, the Sierra Leonean TRC was set up alongside the Special Court for Sierra Leone, a UN-mandated international criminal tribunal designed to prosecute those deemed to carry the greatest responsibility for violations of Sierra Leonean and international humanitarian law during the war, generally Revolutionary United Front (RUF) rebel leaders and their allies, following a request by President Ahmad Kabbah to the UN security council.

The TRC was given the legal responsibility to find the nature, extent, and causes of human rights violations in the civil war. In 2005, they released a report, comprising four books of almost 2000 pages in total, covering the following areas:

- Causes of the conflict
- Nature and characteristics of the conflict
- Perpetrator responsibility
- Military and political history (including findings on factions and individuals involved in the war)
- External actors
- The judiciary, rule of law, and the promotion of human rights
- Youth

- Children
- Women
- Mineral resources
- The TRC and Special Court for Sierra Leone

Among the TRC's mandated objectives were making recommendations towards addressing impunity, responding to the needs of victims and communities, and promoting healing and reconciliation to prevent a repeat of the conflict and its widespread abuses towards Sierra Leoneans. The TRC Act required that the Sierra Leonean government, by law, implement the recommendations of the TRC report directed at them and encourage and assist other groups named as having a share of responsibility for the conflict to do the same. This marked the first time in world history that a government was put under legal obligation to implement at least some reforms recommended by a truth commission—those that the TRC considered 'imperative,' upholding rights and values lacking in Sierra Leone were meant to be implemented immediately or as soon as possible; other recommendations, labeled as 'work towards,' for long-term goals requiring in-depth planning and collection of resources, 'seriously consider,' expected to be engaged in thorough evaluation, or 'calls on,' directed at bodies outside the government, were under no legal obligation to be implemented.

In examining the question of how Sierra Leone descended into chaos, the TRC made a number of findings. They began by stating that the war and period shortly before (causing the conditions leading to the war) to be the "most shameful years in Sierra Leone's history," showing a failure in leadership by many in both government and civil society failing to direct the country away from a slide into bloody civil war.

They explored a number of possible issues offering some explanation for the war, not just failures in leadership and governance, but also the history of post-colonial Sierra Leone, the urge to control the diamond wealth of the country, and influence from other countries, such as Libya and Liberia, in particular Liberia's warlord leader, Charles Taylor. The Commission identified a number of issues, such as the history of military coups and instability in post-colonial politics, and historical local conflicts, whether ethnic, cultural, or otherwise, combining to fuel wider insurgencies, making a number of recommendations based on their findings.

The core recommendations of the Commission included:

- calling upon leaders at all levels to follow new principles of committed leadership
- calling upon the public sector to bring in a new culture of ethics and service to fight corruption that weakens Sierra Leone
- protecting the right to human dignity and abolishing the death penalty
- upholding freedom of expression
- introducing common and equitable citizenship for all to promote a new devotion to Sierra Leone
- strengthening democracy, the rule of law, and accountability in institutions
- establishing the principle of National Security, reflecting the will of the people to live in peace and harmony
- bringing government and services to people throughout the country.

In addition to these findings and recommendations, and while generally having a good working relationship with the Special Court, the Commission condemned the court for abandoning some amnesty provisions of the Lomé Agreement, using the reasoning that some RUF members had broken the agreement (after some sporadic new outbreaks of violence and kidnappings of UN peacekeepers in 2000, following the negotiation of the agreement) and thus were no longer eligible for the amnesty. The TRC pointed out that for any combatants in future wars, any agreement granting amnesty from wartime activities could not be trusted, undermin-

ing the chance for peace initiatives to succeed elsewhere in the world (although the UN has always made it clear it does not accept amnesty for those bearing greatest responsibility for serious human rights violations, which the TRC acknowledged at the time).

This, along with the Special Court refusing the TRC access to public hearings with Special Court detainees, citing security issues and potential conflicts in evidence between that collected by the Special Court and that collected by the TRC, led to tension between the two groups, with the TRC viewing the denial of access to detainees as also denying the rights of Sierra Leoneans to open and transparent access to the process of truth and reconciliation, and disadvantaging the TRC in its work.

While a valuable source of recent Sierra Leonean history and insight into the causes of, and atrocities during, the war, the limited access to the report (with just 4000 copies printed for the entire country) has restricted its impact. The aforementioned issues of trust and access, combined with lack of political will, has led to difficulty in implementing the recommendations and directives of the TRC.

In addition, to many Sierra Leoneans, with the turmoil within and failures of post-colonial government, the concept of 'the state' is an abstract, having no relevancy to their daily lives. Even in the colonial era Sierra Leone was divided into the urban 'Colony' around Freetown, and the rural 'Protectorate' outside, with the colonial government formalizing common law only within the Colony, developing both areas separately and unequally, with two separate legal systems and vastly different social, economic, and political development. The finding of the TRC was that to correct this issue, post-conflict governments must undergo an overhaul in their culture, to more closely engage with the people, prove that they're different from their pre-war and wartime counterparts by demonstrating ownership, leadership, imagination, and

determination, and implementing programs for change to win the trust of the people, monitored by strong and independent institutions –only after this will Sierra Leoneans believe that the correct lessons have been learnt from decades of government decay and ineptitude.

While not a subsitute for effective government and implementation of the TRCs recommendations, this area is one where Fambul Tok can assist, helping Sierra Leoneans to heal and reconcile in ceremonies based on traditional notions of community wholeness, put aside during the war, helping communities to heal, village by village, district by district. By engaging directly with the people and working at a grassroots level, Fambul Tok allows the reconciliation process to take shape, based on the traditional needs and wants of the people involved in a direct way that the government and other larger bodies may not be able to do in the necessary timeframe, if at all.

PLANTS FLUTTER IN THE BREEZE.

SIERRA LEONE, THE WAR, AND THE TRANSITIONAL JUSTICE PROCESS

Joe A. D. Alie, "Reconciliation and traditional justice: tradition-based practices of the Kpaa Mende in Sierra Leone," extracted from Luc Huyse and Mark Salter, *Traditional Justice and Reconciliation after Violent Conflict: Learning from African Experiences* (International Idea, 2008). www.fambultok.org/wp-content/uploads/2010/06/Chapter_5_Reconciliation_and_traditional_justice_tradition-based_practices_of_the_Kpaa_Mende_in_Sierra_Leone.pdf

Ishmael Beah, *Long Way Gone: Memoirs of a Boy Soldier* (Farrar, Straus and Giroux, 2008)

Aminatta Forna, *The Devil That Danced on the Water: A Daughter's Quest* (Grove Press, 2003)

Lansana Gberie, *A Dirty War in West Africa: The RUF and the Destruction of Sierra Leone* (Indiana University Press, 2005)

Priscilla Hayner, Center for Humanitarian Dialogue, *Negotiating Peace in Sierra Leone: Confronting the Justice Challenge* (2007). www.ictj.org/static/Africa/SierraLeone/HaynerSL1207.eng.pdf

David Keen, *Conflict and Collusion in Sierra Leone* (James Currey, 2005).

Tim Kelsall, *Culture under Cross-Examination: International Justice and the Special Court for Sierra Leone* (Cambridge University Press, 2009).

Rosalind Shaw, *Rethinking Truth and Reconciliation Commissions: Lessons from Sierra Leone, USIP Special Report* (2005). www.usip.org/resources/rethinking-truth-and-reconciliation-commissions-lessons-sierra-leone

Sierra Leone Truth and Reconciliation Commission, *Final Report of the Truth and Reconciliation Commission* [3 Volumes plus Appendices] (2004). www.sierra-leone.org/TRCDocuments.html

Sierra Leone Truth and Reconciliation Working Group, *The TRC Report: A Senior Secondary School Version* (2005). www.sierra-leone.org/Text_book_Sierra_Leone.pdf

Sierra Leone Working Group on Truth and Reconciliation, *Searching for Truth and Justice in Sierra Leone: An Initial Study of the Performance and Impact of the Truth and Reconciliation Commission* (2006). www.fambultok.org/TRCStudy-FinalVersion.pdf

PEACEBUILDING, RECONCILIATION, AND RESTORATIVE JUSTICE

John Paul Lederach, *The Moral Imagination: The Art and Soul of Peacebuilding* (Oxford University Press, 2005).

John Paul Lederach, *The Journey Toward Reconciliation* (Herald Press, 1999)

Dyan E. Mazurana and Susan R. McKay, *Women and Peacebuilding* (International Centre for Human Rights and Democratic Development, 1999)

Sara Terry, *Aftermath: Bosnia's Long Road to Peace* (Channel Photographics, 2005)

Howard Zehr, *The Little Book of Restorative Justice* (Good Books, 2002)

Howard Zehr, *Changing Lenses: A New Focus for Crime and Justice* (Herald Press, 1990)

FORGIVENESS

Pumla Gobodo-Madikizela, *A Human Being Died That Night: A South African Story of Forgiveness* (Houghton Mifflin Harcourt, 2003)

Michael Henderson, *The Forgiveness Factor: Stories of Hope in a World of Conflict* (Grosvenor Books, 1996)

Desmond Tutu, *No Future Without Forgiveness* (Image, 2000)

ORGANIZATIONAL DEVELOPMENT

David L. Cooperrider and Diana Whitney, *Appreciative Inquiry: A Positive Revolution in Change* (Berrett-Koehler, 2005)

Dee Hock, *One from Many: VISA and the Rise of Chaordic Organization* (Berrett-Koehler Publishers, 2005)

Peter M. Senge, C. Otto Scharmer, Joseph Jaworski, and Betty Sue Flowers, *Presence: Human Purpose and the Field of the Future* (Crown Business, 2008)

Margaret J. Wheatley, *Leadership and the New Science: Discovering Order in a Chaotic World*, 3rd ed. (Berrett-Koehler Publishers, 2006)

The family conversation goes global. Fambul Tok is launching a multi-year, multi-platform, multi-continent conversation on reconciliation, beginning in early 2011, with an in-depth focus in the USA, in Sierra Leone, and in the United Kingdom. In addition to this book, the conversation is anchored by several key components.

THE FAMBUL TOK PROGRAM IN SIERRA LEONE
WWW.FAMBULTOK.ORG

This is at the heart of it all. Inspired by Sierra Leone's "family talk" tradition of discussing and resolving issues within the security of a family circle, the program works at the village level to help communities organize truth-telling bonfires and traditional cleansing ceremonies—practices that many communities have not employed since before the war. Drawing on age-old traditions of confession, apology, and forgiveness, Fambul Tok has revived Sierra Leoneans' rightful pride in their culture. The program requires community ownership at every level and, as such, charts a new path for the international community in post-conflict reconstruction. Active in four of Sierra Leone's fourteen districts, the program will roll out in three new districts a year, covering the whole country by 2013.

FAMBUL TOK: THE FILM
WWW.FAMBULTOKTHEMOVIE.COM

An 82-minute feature length documentary, directed and produced by Sara Terry, and produced by Emmy-award-winner Rory Kennedy and Libby Hoffman, to be released in early 2011. *Fambul Tok: The Film* gives audiences a seat at the truth-telling bonfires and an unsparing, life altering look at the legacy of the war on the people of Sierra Leone and the courage with which they are transcending it.

The film is also available in foreign language, educational, and how-to versions.

FORGIVE ONE THING: COMMUNITY SCREENINGS IN THE USA AND UK

A widespread community screening campaign is engaging community groups across the US and UK, with a study-discussion guide to facilitate dialogue, and drawing connections between Fambul Tok and our lives. After seeing the film, viewers are immediately engaged with the question of forgiveness, and are invited to engage in further thought and action through our Forgive One Thing campaign:

Forgive one thing – because the world doesn't change until we change. And we do that one step at a time, in one act of forgiveness, one moment of peacemaking, one instance of saying you're sorry to someone you've wronged. For Westerners, it may seem impossible to forgive the kinds of atrocities that Sierra Leoneans are forgiving in villages across their country. But we can start somewhere – whether it's the person who cuts you off in traffic, the family member you haven't spoken to in 20 years, or the ex-friend who still owes you $100. Because that's how peace begins – first in our lives, and then in the world. So start by forgiving one thing. And while you're at it, say you're sorry for another.

Share your story and join the conversation on the Forgive One Thing page at www.FambulTokThe-Movie.com. Visit the film website to schedule a screening in your community or to order a DVD.

THE WI NA WAN FAMBUL (WE ARE ONE FAMILY) NATIONAL CAMPAIGN IN SIERRA LEONE:

Community screenings of the film in over 160 villages across the country, building on the grass-roots success of the Fambul Tok program to build

a national reconciliation movement and support violence-free national elections in 2012.

EXHIBITIONS

Designed to accompany screenings of the film, the exhibition sets of twenty 17 x 22" color prints (of many of the photos featured in this book) are designed to hang in informal settings, available for organizations that want to exhibit the photos for several weeks as a way to continue the dialogue begun by a film screening.

WAN FAMBUL (ONE FAMILY) MUSIC CD

A full-length compilation album featuring a selection of emerging and established musical stars from across the globe, from which 100% of proceeds will go to Fambul Tok. Available both as a physical album and a digital download album off Fambul Tok's website (www.FambulTok.org), it includes a full-color CD insert (or PDF download for the digital album), complete with original artwork and information about Fambul Tok, the project, and the artists involved.

EDUCATIONAL CURRICULUM

Designed for high school and some middle-school audiences, this forty-page full-color publication, with accompanying DVD of the educational version of the film, takes the stories and lessons of Fambul Tok and makes them accessible to students in a multi-cultural curriculum, accompanied by a teacher's guide and poster. As more classrooms engage with the concepts of Fambul Tok, Fambul-Tok.org will continue to develop online resources, maintain active forums, and seek out innovative ways for western classrooms to connect with, and learn from, the villages of Sierra Leone.

For further information please contact:

Libby Hoffman, *Fambul Tok International*
+1 (207) 775-2616
lhoffman@fambultok.org
www.fambultok.org

Nan Richardson, *Umbrage Editions*
+1 (212) 796-2707
nan@umbragebooks.com
www.umbragebooks.com

Fambul Tok gratefully acknowledges the generous support to date by the following foundations and organizations:
Catalyst For Peace
Sundance Documentary Institute
IFP
UNWOMEN SIERRA LEONE
New Field Foundation
Sigrid Rausing Trust
JSL Foundation
Devito-Perlman Family Foundation
Judith Glickman Foundation
Cohen Family Foundation
Patricia Heaton and David Hunt
The Compton Foundation

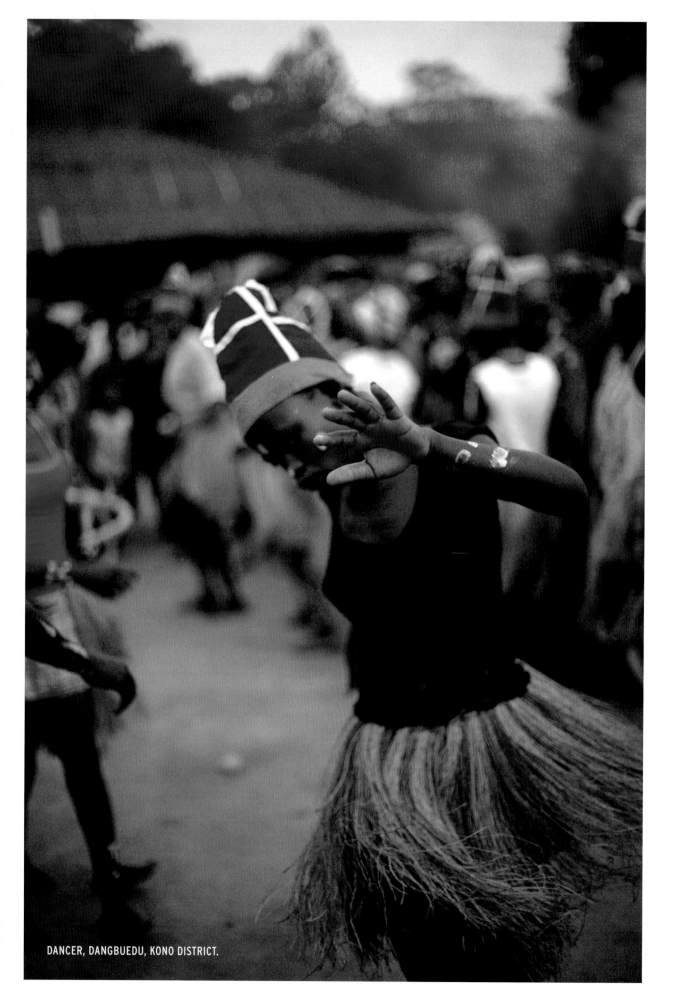

DANCER, DANGBUEDU, KONO DISTRICT.

This book owes its greatest debt to the people of Sierra Leone, whose courage, creativity and resilience have yielded such a rich harvest of lessons. We could not imagine a more dedicated, generous, wise, patient, and inspiring group of people than the Fambul Tok staff and the volunteers who lead the program in the districts. Their willingness to sacrifice for the good of the whole is without match, and it is the good soil from which the whole Fambul Tok program springs.

The staff members who have helped shepherd this process to this point include: Marian Abu, Michaella Ashwood, Mohamed D. Bah, Hassan Bangura, Helen Bash-Taqi, Joseph Benjie, Alhaji Bockarie, Tamba Bockarie, Adenike Cole, Bintu Conteh, Mohamed Dawo, Mohamed Feika, Abubakkarr Foday, Mariama Foray, Tamba Kamanda, Saidu Kamara, A. Tejan Kamara, Manteneh Kargbo, Mohamed K. Kargbo, Musa Korpoi, Prince E. L. Koroma, Sheku Koroma, Lamin Mansaray, Maseray Mansaray, Yusifu Mansaray, Peter Mboyawa, Lilian Morsay, Tamba Nyama, Robert Roche, Mustapha Rogers, Ibrahim Sesay, Isatu Masu Sesay, Joseph Vandi, Rosamund Williams, and Solomon Yarjoh. Our Peace Mothers have brought unbounded energy to Fambul Tok and to their communities, and we have special gratitude for the leadership of Mariama Koroma, Isata Ndolleh, Alice Allieu, Alice Lebbie, Bintu Gbanga, Malanga Jawara, Maso Kerah, and Agnes Sowa. A lion's share of the work of Fambul Tok falls on the Chairmen of the District Executives, and we have been blessed to have the wise and committed leadership of these outstanding District Chairmen to date: Chief Maada Alpha Ndolleh, Paramount Chief Alfred Ndomawa Banya, Chief Raymond Komba,

and Reverend Emanuel Sesay. The hundreds of other volunteers, throughout all the districts, are too numerous to name here individually, however their images are in the pictures and their spirits infuse each line.

Many other people uniquely and importantly contributed to the program's development along the way. The Practice Institute at Eastern Mennonite University's Center for Justice and Peacebuilding has been a valued partner in Fambul Tok from the beginning. Associate Director Amy Potter Czajkowski has been by our side in this work from our first in-person meeting. She provided the initial reconciliation training for Fambul Tok staff and volunteers that seeded the entire training program. Her wisdom, patience, expertise, and commitment have benefited us and the program greatly.

Jon Lunn has been a key partner and co-visionary with John from the earliest days of Forum of Conscience, where his courageous and wise support helped launch and cultivate the human rights work in Sierra Leone that became foundational to Fambul Tok. His generosity with his time and talents continues to strengthen our work. Bruce Jeffrey has been a strong support for Libby from the earliest days of Catalyst for Peace, and his clear thought, deep faith, and great gifts for all-things-organizational have been foundational in cultivating the structures that sustain the work of Fambul Tok.

Bryan Martin and Rick Augsburger of The KonTerra Group have shepherded us organizationally from the earliest days, patiently dealing with our non-linear ways and helping to draw out the best of

what we know. Although they like to think of themselves as "outside" consultants, we think of them as cherished members of the Fambul. Tammy Mazza has kept us sane and our numbers in order. Braden Buehler has brought beauty, power, and eloquence to our communications. Many others have played important roles for us as Fambul Tok has evolved, including: Angie Lederach, Claire Putzeys, Heather Woodman, Usman Fornah, Lois Carlson, Benedict Sannoh, Ishmael Beah, Cynthia Sampson, and Charles Gibbs.

A special thank-you goes to everyone involved in making the Fambul Tok film ("Fambul Doc," as we affectionately call it), without which it is unlikely this book would have come into being. Rory Kennedy helped us see anew the value of the work and the ideas behind it, and introduced us to the incomparable Nan Richardson, enabling the publication of this book. We bow deeply to Nan and her team at Umbrage (Daniel Wilson, Unha Kim, Antonia Blair) for the tireless work it took to herd us to completion, and for the incredible skill with which they make all of our words and work shine.

Our grateful thanks for their generous support to the Compton Foundation, who have helped to make this book possible.

FOR SARA TERRY

It's difficult to find words to thank you. Your photographic eye does more than simply yield stunning photographs. You embody Ben Okri's call for a "new seeing" of Africa in "its brightness, its brilliance, its beauty. If we see it, it will be revealed. . . . Only what we see, what we see anew, is revealed to us." Your clear-eyed, fearless, affectionate, and generous "seeing" of Sierra Leone has been an important part of opening up those worlds for Fambul Tok. We hope, through this book, they can help open up new worlds for others as well.

FROM LIBBY

I owe a special debt of gratitude to all of the participants in the United Religions Initiative's Moral Imagination Program and to John Paul Lederach, Herm Weaver and Barbara Hartford, in particular, for providing what I call the "gestational space" for my own peacebuilding practice values to come into clearer manifestation, paving the way for Fambul Tok to happen

My deepest gratitude goes to my family—my children Caleb, Gabe, and Anna, who inspire all that I do—and especially to my husband Seth, whose companionship and support ground, empower, and sustain me always.

And finally to John Caulker, what can I say? I can't imagine a greater gift than being able to walk this journey with you. I learn, and am inspired and re-inspired, every day. Tenki.

FROM JOHN

A special thanks to the many friends and colleagues who accompanied me through my 14 years journey with Forum of Conscience. You gave me courage and inspired me to take on my present task at Fambul Tok. Particular thanks to Bunton Rogers-Wrights and David Tam-Baryoh, Chairman of the Board of Director of Forum of Conscience, and all others who are part of the NETWORK of Human Rights Defenders in Sierra Leone and the Mano River Union (MRU).

I owe a debt of gratitude first to my parents: Marvelous and Annie Caulker (late). And my family—my daughter Chalwyn, nephew Albert Caulker, Quindran Cole, niece Patricia Macauley, brother Marvellous Caulker, and my dear wife Esther, all of whom have been a constant source of support and inspiration every day of my life as I navigate the difficult path of national healing and reconciliation in Sierra Leone.

And finally, to Libby Hoffman and Family, thank you and please continue to stand side by side with the people of Sierra Leone as we as a nation collectively work towards healing and reconciliation at the community level that will usher in sustainable peace and development through out Sierra Leone.

Libby Hoffman
Falmouth, Maine
USA

John Caulker
Freetown
Sierra Leone

FROM SARA

There are few times in a journalist's life when you know that you stand on "holy ground"—on the terrain of a story unlike anything you've ever covered, of a story that flies in the face of conventional wisdom about a people or place.

This is what Fambul Tok has been for me—and the challenge and the promise of the journey through this landscape has been made all the more meaningful by the companionship of Libby Hoffman and John Caulker. They have been true friends and visionaries, and the work would have been impossible without them.

As a storyteller driven by the desire to understand what it means to be human, I am deeply thankful to the people of Sierra Leone—and their daily lessons on the magnificent subject of forgiveness. I believe your example will lead the world.

Fambul Tok
An Umbrage Editions Book

First Edition

10 9 8 7 6 5 4 3 2 1

ISBN 978-1-884167-21-8

Umbrage Editions, Inc.
111 Front Street, Suite 208
Brooklyn, New York 11201
www.umbragebooks.com

An Umbrage Editions book
Publisher: Nan Richardson
Associate Editor: Antonia Blair
Office Manager: Valerie Burgio
Designer: Unha Kim
Design Assistant: Liz Johnson
Editorial Assistant: Daniel Wilson
Editorial Intern: Samantha Richardson

Printed in China

Distributed by Consortium in the United States
www.consortium.com

Distributed by Turnaround in Europe
www.turnaround.UK

Our grateful thanks to Sidney Kimmel for his support.

Notes:

Page 105:
1) M. Mitchell Waldrop, "Dee Hock on Organizations,"
Fast Company, October 31, 1996.
www.fastcompany.com/magazine/05/dee3.html

The interview with John Caulker was conducted by Nan Richardson
in New York on July 20, 2010 in and supplemented by Fambul Tok
film transcripts and interviews.